lloyd robson is a poet & prose writer whose texts spill over into typography, photography, visual art & performance. he has completed reading tours in britain, germany, the usa & japan. he is also a workshop tutor & recovering journalist. he was an all round general pain in the arse, but seems to be over that now.

he was born in cardiff & has lived in cardiff, cwmbran, herefordshire, monmouth, cardiff, plymouth & cardiff. his accent is a shambles & he speaks with a stammer. for more information on stammering & dysfluency contact the british stammering association, 15 old ford road, london, england, E2 9PJ or visit their website at www.stammering.org

publications include 'cardiff cut' (parthian books), 'letter from sissi', 'edge territory', 'city & poems' & the cd 'shush!' (blackhat) & 'at the cairo café' - a poem engraved into the pavement on bute street as part of the cardiff bay arts trust public art programme. previously, he co-wrote with phil coles the south glamorgan health authority drugs education magazine 'the bizz' & was an early features editor for 'the scene' magazine in plymouth.

visual works include the 'sense of city road' photo-poetry montage first exhibited on city road in cardiff (2000) & a series of visual texts commissioned by the cardiff bay arts trust (2001). two images from the 'sense of city road' montage were included in the royal cambrian academy's 'young wales V' exhibition (2001).

in 2002 he was appointed writer in residence at the university of wales college newport school of art, media & design.

for further information visit www.lloydrobson.com

bbboing!

& associated weirdness

or
somebody stole my ritalin

lloyd robson

PARTHIAN BOOKS

Parthian Books
The Old Surgery
Napier Street
Cardigan
Wales
UK
SA43 1ED

www.parthianbooks.co.uk

First published in 2003
All rights reserved
© lloyd robson 2003
ISBN 1-902638-29-8

Typeset in Foundry Sans & other fonts by
lloyd robson

Printed and bound by
Dinefwr Press, Llandybie, Wales

Cover by Marc Jennings

The publishers would like to thank the
Arts Council of Wales for support in
the publication of this volume

With support from the Parthian Collective

The author wishes to acknowledge the
award of a Writer's Bursary from the
Arts Council of Wales for the purpose
of completing this book

A CIP catalogue record for this book is
available from the British Library

contents

to the end & to the beginning

crash

▶

CRASH.

twelve twelve 86.

M50 ross to M5 brumbound motawaylink junction 3 sharp 90 degree lefturn onta B4221 signpostd:

Newent

about half one ina morning jus left party
woke ina hospital
shitfaced.

kinda bombing down doing ova a ton hita sudden bend
still accelerating
went

insteada negotiating

dida torvill

until we stopt orbiting

allfour wheels hit the ground witha straight

| perfect |
| **6** |

landin

(bluelites synchrospinning with aar car
iss double axle axel wins a record score)

us, inside: still

me mate at the wheel & me ina back
brunette in frontseat
her blonde friend
with her head
in me lap
giving
her
a
lift home
to save the cost of a cab
(yeh, right!...)

pulld off
to take home

THREW UP

before she could open
the window

the girl ina frontseat

LUMPT

from her hair down

wishing
she had foned dad/cab
for a lift home

wishing
moments later
all the more so...

took off
froma stuntd sliproad

pulld out
thinking:

i can feel myself

growing old;

best not be here

when we land

CLOSE YOUR EYES

it'll be

alright

BE CALM

survive…

before that: saw nothing
(bar roadsign & screama catastrophe...

headlites bounce
off colourcoded touchstone
the road upa head
pointd down

war
d)

blackt out
jus pas take off,

misst out

THE BIG ONE

in

nanotime

...

▶

hardshoulda cutup:

flyove)))

decades before built

land at convergence of powaline/the alternate crosscurrent

 COLLIDE

(the height of the winta nitesky
 the deeplycreep barrage of showtime

a trench of vision
 the sight of excavation

 - a cast of hawks
a labour of moles -

leaves
me

blind);

cwtsh bosom angle as

BUZZ

LOUDA

til

LOUDA

til

OUTASIGHT

POWA

FUSEWIRE HI

I'M

GOING OUT!

o fuck my tall hat

am i going out...

: pent kerb.

doubleflip tumbledown verge & spentfield windscreen merge
wi greenyield & mud

chassistwist **THUD** refusal of earth/groundsmak dirge
sounds of the energies
in turmoil.

inside the car:

 bodies everywhere;

 frontseat/backseat/floor
 steerwheel embossed on the driver's ribwall
 the brunette upfront climbd
 dash/thru screenhole

BBBURST
inta nite cold

me mate out the rentdoor draggd me thru the hatch
(the cheapseats came off the worst)

she
whippt
to the backfloor

she
halfasleep as she *flipt taut*
the torque of her back in reverse of her spine's hold
reined to the floor
they told her:

DON'T MOVE!

WE'LL GET YOU OUT!

...any second now.

i

gettin *DRAGGD OUT*
via the hatch

gettin *LLAYD OUT*
at the foota the verge, away from the surge of adrenalin

unconscious

someone fetch me
a blanket

keep my head

always visible

promise...

▶

woke in a puddle.
in mud in blood in cold in wintablue & gold & in

BIZARRELY ENUFF!

serene temperament.

while all around me:

madness

(bluebrown rain smakt fourwheel furrows & ancient puddles
HUBDREDGD
out of all existence

liquid reshapt
into

first algoid disturbance in ages)

blue lite & radio
tyre burr & uniform
hedges & pylon

the remains ofa fiat. fences. barbwire riprapt round axles
(we pulld out the stitches in slo-mo)

mudpools & pylons, blood fuel & alcohol
debris ragesprayd like a stanleyblade in the hands
ofa complete fuckin nutta

(unutterable calm ofa mind
exorcised from inside its own damaged shelter)

groundfrost of early winter

momentary glare from the passing of motavehicles

temporal & ethereal in molecules

feeling aware of the pain
& the distance
between
us

alive in…

minutiae & legion.

▶

my leftside of head: bleeding.

quarterlite handle caught in me earhole & wouldn let go til
we landed

(couldn't find it witha mouthful of vomit
i ruptured my vessel ova frontseat occupant

it hit her moments before
we had impact)

ript to me chin expounding the basic vulnerability
of jawline

(blood ript from veins & skin from skin
thru smasht triplex & skagged the
rim of pain management)

she cut me tidy

(felt myself drip
from the constant blue tinge
of reality…)

▶

pylons march ova blackpurple heavens
seedheads flare with my pump pulse vision

(close them)

(close them again)

pylon hover in the lite of the motaway
pure throbbing force in the strobe possibility of danger

constant blue tracers from voices
of unrecognisable people:

THE AMBULANCE IS HERE NOW!

(think i'll

blackout!
til the enda
the journey...)

▶

flashfall of moment:

opend me eyes to the surface, registered close action & the
nearing of ambulance, caught the silverfoil chill from the
screwtwist frontgrill as they carried me onward & upward,
banging me into this big flashing chromecase of brightness...

BUZZ
LOUDA
as
NEARA

as waking on stretcha to visions of leaving:

> fast transport of current energy
> snippet of road correspondence
> increase in cranial activity
> positive signs of existence

THUD doors

& the slowdrive to hereford

(i'll be out of it then, see you there, yeh?)

> drift out
> still pisst up
> still
> silent.

▶

woke ina meatwagon moment; facemask &

HE'S COMING ROUND!

announcement

thinkin:

THIS IS MADNESS ISS MADNESS IZZ CRAZY

(that's alright then, i'm pleased, besta luck to him)

strapt in & drift unda blanket; pass in & outa
confusion - conscious - the flow of pure oxy - alignment...

come round to the whirlrasp silence
siren relief, shock treatment

update
&
get back to me haven

fora moment
i thought
i was

distant/ce.

CODA:

TWO MEN/TWO WOMEN PULLED FROM REDFIAT RUSTRAP, TAKEN BY HEREFORD AMBULANCE CALLED TO THE SCENE BY THE TRAFFIC POLICE WHO WERE SAID TO BE TAILING FOR roundabouts. ALL REPORTED AS CONDITION alright FINE fair to middlin TOUCH & GO flickerin between okeydoke & purely SURVIVING. still alive lucky bleeders still breathing.

REPORT IN THE HEREFORD EVENING NEWS, FRIDAY 12.12.86; A TACKED-ON FILLER (FOOT OF PAGE THREE), NO BYLINE, JUST BARE BONES OF STORY:

> And four people were taken to Hereford General Hospital today after an accident on an M50 slip road.
> Police say their vehicle ran off the carriageway just after 1 a.m., careered down an embankment and rolled over.

& continues to roll
ever after…

michaelwood

▶

been standing michaelwood for hours. still raining. third time
that policecar's checkt us bastards staring buzzing the afflicted
cold & glaring from inside their battenberg staring always
fucking staring

> *"so we got towels on aar eads: fuckin what!?*
> *fuckin raining..."*

ink on our sign saying *'ANYWHERE'* running.

no stimulus. stuck on this motaway service station sliproad.
used up all our jokes, sick of reading lorry livery as they pass,
kiosk windows, petrolpump logos...

> *(petrolpump singalong!*

> petrolstat desertstorm singalong
> roadside totem worst scenario
> coming down the wires
> any second now:

"UK/texaco: Q8 Esso..."

(JET: Mobil)

*"BULLDOG BULLDOG
BP Anglo,
thrust POWER imperial.
ACTION LittleDavid
PRONTO, i repeat: ACTION
LittleDavid PRONTO..."*

(static fuzz his only answer…)

"BULLDOG!
BULL! DOG!
BP BFL Anglo!
3D H POWER PRONTO!
H ACTION ANGLO!
POWER LittleDavid!
POWER thrust imperial!"

"FIRE you stupid fucking
SF Esso BRITISH BENZOL REPSOL
flying fucking pump attendant

FY-URR!
you bastard

FY-YURR AT WILL!!!"

ELF.

ALLSTAR
Agency
OVERDRIVE

AMERICAN EXPRESS
Access MASTERCARD

"BOMB EM FROM THE SKIES"

on the fuselage.

Shell: AMOCO
Gulf: TOTAL...

NEXTDAY:
another tuppence
on petrol).

▶

policecar five an hour & closing. still staring. pokerfaced we return their overbearing contact *(contact? contact!? bleedin cuntact more like it, bleedin cuntox the paira them... no surprise then)*.

eyebrows dripping, raineye stinging, wetnite permeates every inch of aar being.

al walks back to the bogs, hunt the blim he dropt earlia. shop for some rizla. all our skins stuck together.

cuntocks.

cun cun cuntox
cuntinell fuckin fat twat raindrops cuntinell fucking wanker
getting fuckin sodden here

 (cunt : colloquially the female genitals
 more commonly a right fuckin bastard
 funny cunt if ya lucky
 best not ta confuse em if help it

 (cunt : cynd cunnus cunt
 konnos kunta cunny kunté
 con conno ku

"cunt to you too ya starin fuckin bastards in ya nice dry saloon"

 (: queynte quoynte quonium
 chamber of venus
 bele chose
 cone-ee

 (: coney / cony rabbit
 coney / cony island
 coney / cony beach

(lying there listening, the lap of the c)

 (: cunny / cony
 cunny / cony
 cone-ee
 cone-ee

 no money / no coney
 no money / no coney
 no cunnus cuniculus cunnilingus

fanny

(: rabbit burrows or passage

 cunnies & conies
 cunnies & conies
 no pussy

(: cunny warren / cunny hunter
 bunny

(remains on the side of the motaway)

(: i'll fight for my cunt / i'll fight for my cunt
 i'll fight for my cunt-er-ee

 since the beginning
 of the eighteenth century
 the word has been held
 to be obscene

(print it / in full)

 the english dic
 tionary
 first in
 first in
 the sixties

(fuck me)

(: *acquaint a quaint cunny?*
 un fuckin likely...

 cunstable con cunt cunning
 constable / thingstable

 a word full of
 cunny punning

"evening officers, all alright with you?
minds if we stand here? this a fuckin zoo? trunky wanna bun?

(you shiny fuckin buttoned scum)

man i fuckin hates hitchin ina rain, fuckin mug's game..."

al comes back unsuccessful. this is getting to be a right pain in
the arse if you gess what i rectum.

(jus wanna get home; some warm & sleep...)

"look at em: fuckin cuntox the lota them"

 (: renta cunt
 diala cunt
 full moneyback guarantee
 cunts on wheels
 cunt mobility
 cunt replacement windscreens
 cunts for you & me

 (: west mercia traffic cunts
 unmarkt policestop cunts
 cunt limousines

 cunts scoffing some
 deepnite neon mcCunt speciality
 hot muffin to go!
 as you please

 (: cunts checking hitchers
 for the sake of exuding inequality

uniforms in jamjar mentality

you gota warm car but i got me mate wi me
no contest pal
you c.u.n.
c.u.
constabulary

(: fuckin motorised twats
morals mixt & matcht with upholstery
easy to wipe clean.

(: these people were cunts & proud of it:

gunoka cuntless	belle widecunt
godwin clawcunt	simon sitbitcunt
john fillcunt	robert clevecunt

(history)

(: made fast to the gropecunt lane

(: privily he caught her by the
queynt above the knee

(: netherland holeland the low cuntry

(arse anus rectum smudgebowl
circle ringpiece quiot or rumpole)

(: 'sunt' with a 'c'
abominable

(: grumble & / grasp & / growl & grunt
sharp & blunt / berkeley hunt

(: see you next tuesday
 c.u.n.t.

 t' nuc
 t
 nuc
 e...)

we remain watching traffic passt three. spend hours, feel the rain turn to sleet. a change in the lite means they can now see our features. gess a lift from a drugs truck on a routine niteshift. takes us: down the line; eventually.

me & al take turns to speak; provide periodic grunts to the talker in the driver's seat. by eight we gess dropt by new sainsbury's.

sun's out. on a fine weekday morning. we walk marshmills to mount gould river plym to st. judes & i can jus see me street. soon eat, dream of sleep, cunts & motaways.

tour notes (& comic titles)

▶

first gig of tour & miles deep into thüringer forest. crazy drive, single track up & down thru bristle of pine; valley track to fuck knows where. peer thru the halflite: expect ***ANY SECOND NOW!*** red army jeeps blocking the way. guard against woods, waiting for search lites, bulletspray, borderstrafe, action man™ sentry box & comic strip raid. the boys & me are:

PANZER TARGET
THE GHOST BATTALION
DEMOLITION SQUAD

THE MISFITS
THE BOUNTY HUNTERS
THE DEATH OR GLORY MOB

THE SHARP-SHOOTERS
UNITED IN BATTLE
RIDERS OF TERROR
SHOULDER TO SHOULDER
WARRIOR BREED
FIT TO FIGHT

BRING 'EM BACK ALIVE!

these trees have eyes, i can sense them:

THE IRON FOREST

FORTRESS COMMAND
HOODOO MISSION
BRING ON THE TANKS!
INTO THE WOLF-LAIR!
INTO THE TRAP!

MARCH INTO DANGER
BEHIND ENEMY LINES
FINGER ON BUTTON
FORWARD THE GUNS

THE COBRA'S NEST
NOWHERE TO HIDE
DANGER AHEAD
RUN FOR YOUR LIFE
DANGER EVERYWHERE!
ESCAPE - OR DIE!

ONE FALSE MOVE...

DEATH IN THE HILLS
VALLEY OF FLAME
HAIL OF STEEL
CROSS FIRE
DEATH RAY

RADIO SILENCE
TRIGGER TRAP
JUNGLE MADNESS
SITTING DUCK

can't relax til i get out of these trees man. doing me head in, know what i'm saying.

i'm sat in the back of the van. we're following the germans. outside: sunshine breaks on concrete lines. i'm examining

skies: birds of prey at flight & fight...

AIRBORNE
ROCKET BLITZ
THE ANGRY SKIES

PIRATE WITH WINGS
FIGHTER ALERT
TIGER IN SKY

ACHTUNG - TEMPEST!
ENEMY IN SIGHT

DUEL TO THE DEATH
A GAME OF CHANCE

SPEARHEAD
ON TARGET!
FULL IMPACT

WINGED DAGGER
BATTLE STRIKE

STOLEN SPITFIRE
FALL FROM THE SKY

CRUEL HARVEST
BOSS OF THE SKY

the birdlife out here is immense. wild. & i'm not jus talkin feathers neither.

★

we reach venue at top of the mountain, a bald stretch of commonland battling shallow against gainsta depth tide of

trees, deep trees. still got this feeling of watching me. streetlite deficiency paranoid.

we meet the locals. the doorstaff muck in with the unload & we move our stuff into a fat fuckoff dancehall, good six foot high stage at the far wall. curtains hide the backstage table with biers on - compliments of the boss we're told. we set up the gear. the lite falls. soundcheck then nip out for a sly smoke, nose around & the rain *holds* the air, no need to go nowhere, both threatens & fulfils at the same time, cloud so low & so still as i roll, spark up & suck in & i'm stood tryna light up a stormfall. never stood in a german cloud before. this place is borderland: east-west, in-out, above-below, crackles with the threat of storm...

<div align="center">

DARK MOUNTAIN
MENACE MOUNTAIN
SUPERFORT!

FORT STEADFAST
STORM CENTRE
WARRIORS ALL

ESCAPE TO NOWHERE
NORTH TO DANGER
HERE'S TO FAILURE
SLOW TO ANGER

THE SECRET WAR

BRAND OF COURAGE
STAND AND FIGHT
PLAY HAVOC
DEAD OF NIGHT
FORWARD THE TIGERS!
TIME UP FOR TRAITORS

</div>

INTO THE ATTACK

stub out me fag & get back & i'm only taking the photographs, what the fuck am i getting so nervous about? will this place let me go when the nite is out? ever again, let me out, will i stand in a thundercloud & smoke away forest rain ever again?

i'm beginning to lose it, bigtime. asking questions i know sweet fuckall about, except from war comics.

the gig's going fine. except they're expecting a three hour set. well they ain't gonna get it, they'll get a fifty-set twice if they're lucky. next thing they'll be asking for 'rawhide'.

lager & rollmop sarnies at half time.

i take some black & whites, finish roll, change to colour, hide in folds of bloody big eighteen foot curtains, get some fly's eye close-ups for certain: mic shots & strumming hands, drumsticks & chrome hot lines reflecting stagelites off of drumstands & cymbals, vocal facials, the blur of a plectrum, pick action.

me camera breaks down for no reason. no wind-on, same problem for ages. i've been banging its lights out since me fourteenth birthday - me dad give it me, in a big fuckoff flightcase of equipment. used to use it himself, then upgraded. fourteen years eighteen days we've been together & i've been brutal in treatment, fuckt her right over when all that she needed was a bloody good servicing. a marriage of non-convenience: i can't afford to fix her nor replace her, so get on with it. i give her a battering but she keeps on, works then

gives up when i need her most, on occasions, like standing on a stage in deepest thüringer, first night of tour, trying to catch all the colours in time with the shutter, catch a vision, frame the corps, *then* she decides on strike action.

every time we hit the stage of *i really gota justify my faith in this cheap equipment*, this fuckt up shagged out & past its sell by date warranty guarantee bleedin temperamental piece of shit every time i need it to power home the same thing happens: nothing; it stops working; refuses to wind on. it'll stick for minutes, hours, days & then will work again for no apparent reason. so it has stopped working. it is sulking. or dying. i am tempted to whip it with its own strap but instead pack it away til i'm ready to test its endurance to test my patience again. give it a rest love her, use the snappy. i will have to invest in new equipment, blast a giro in jessops. the giro someone else is signing for while i'm in germany - told the dole i was in a tent in cornwall while looking for work. *work in cornwall?* you'd be lucky, couldn't think of anything more ludicrous or less believable.

but i know fuckall about cameras do not read magazines compare notes enter competitions buy piles of filters study f-stops, i whittle away at me camera taking tons of shots & regret most of them after. get them developed & *oh yeh man that worked then!* like i knew exactly what i was doing. the buzz of having achieved a little something for the weekend's visual stimulation. work tools & jigsaws of fotograffic storage & retrieval, capturing so much information in a roll of exposure, just so long as i remember to wear me specs. i admit it: i am a truly shambolic photographer, but enthusiasm & instinct are my excuses.

couple of support shots from me coat-pocket snap-in-one. exit stage left, get a round in for when the boys come off stage, compliments of the house. set up the merchandise, prepare for

the rush.

sales are pretty tidy really. for a first night the prospects are promising. i tout, man the stand, walk around, take the cash, chat back when a woman asks:

"how much iz ziss uh, uh cassette bitte? und ze poster? will the band sign it me please? will you ask them for me? will they mind? & you sign it me too yes, you will also?"

sure. don't mind if i... if you say so.

the boys are a different matter. a big fuckoff forestry worker spluttering lager this his big night out, clatters me lugs with his:

"nein nein we do not want any of your shit english pop music you did not play songs by bryan adams not queen not scorpions not springstein so you go away now please you you you english bastard gentleman!"

the woman adding:

"but i want a cassette" (in german) *"how much iz it?"*

fünf mark bitte, i guess. whatever, cheap at half the price. bit of patter, so polite, we flirt out the price. cash changes hands, i stash it for the band, place tenderly her change in her outstretched hand. currency transference. nice.

"now go away englishman"

her boyfriend demands.

i'd tell him i'm welsh but if he did understand it still wouldn't alter the fact i'm cramping his style. i'm a man & for a while there, intriguingly foreign.

whatever you say mate, yeh tschüß, bye, see you later. i move around the room until the sales are shook loose, money in my hand. join the boys, hand over the cash, drink the rider dry & smile at who looks.

★

we load up & go home in two vans. one for the sound crew & one for the band. one of our boys goes with the german lads in the interests of eurostate comradeship & the uncomplicate comfort of a frontseat, a window, decent sounds. we follow their lites in our fuckt up old bedford van.

we drive a few hours. reach macdonald's for lunch/dinner/ breakfast/brunch, i dunno, whatever they'll fuckin well serve us when we realise:

"they've just closed on us now! just now! no serious, straight up, just closed on us just as we're nearing, can you believe it!"

for fucksake we're starving. the shut sign's still swinging we were so close so almost, still swinging the glass, the door the latch the handle i grab & give rattle til tillstaff at least turn to watch me complaining. they don't get away with any less than a bollocking. they do not give a fuck. they've been working all night. makes all of us. wish i'd swiped that last rollmop from plate before leaving but too late, i remember myself saying:

"help yaself mate, i've had me fair share... yeh i'm certain, i expect another plate'll arrive any minute..."

fucking didn't.

"come on man, back in the van, we'll find somewhere to eat, no problemo."

no problemo my arsehole, i'm starving.

we get back to the chalet by seven. raid the fridge. bier, sarnies, crisps. spend time scanning satellite for the so-called english language. we find sky news, that's about it. choose the space channel instead so we can check out before bed some orbiting shots of our planet. it's amazing how close, the view from above, how close a weißensee chalet so close is to cardiff.

the boys crash in the next room, in bunkbeds. i fold out me settee, get some zeds. fall asleep to the sounds of the tourists surging fresh energies for the day ahead. through the window i squint a german, topless bierbelly bloke with his washbag & soap on a rope, hear him farting. tomorrow, this time of day, iss confusing. get me head down, some sleep, don't know if i'm coming or going.

face the wall. get some shadow. think of all the cassette-buying women who talked. tomorrow: gotta get a bloody big curtain, that much i do know, for certain.

★

eleven o'clock sunday off. up, cuppa, trudge the road to the payphone next to the shop. crack open a bier. phone calls to ccfc to catch up with the playoffs. get back to the chalet to find the germans are here with more bier, skins & crisps. we sit & watch the grand prix. it's fine listening to the german commentary but ten minute ad breaks made it hardly worth watching. go for a walk round the lake, green with algae. take biers to the pondside & drink & talk with frogs ribbitting. stroll to the fort. take fotos in front of a fuckoff great catapult, imagine getting flung over battlements, landing in a vat of oil. get back to the chalet & climb in the van. drive into town. buy booze by the crate, visit someone's flat. our hosts cook up dinner - hot russian soup. we drink altenburger premium herb,

talk zappa & beefheart (they know more than we do), the taj mahal concert we watched on the satellite & THAT drum solo. drummy talks stickspeak about how it ain't in the shoulders cos the arms ain't fast enough, it's all in the wrists man the wrists, that's where the power's at. we point out that's his excuse, reckon his wrist gets plenty of exercise.

& poetry man. i give em books, get introduced to schwi schwi schwitters & passed collections to peek at, give sound & concrete poems a first view. get greeted by friendly pages, listen to the ursonate, follow syllables & lung swoops. breaking through. talk of badgers & flowers & all the fucking wildlife we've seen rabbits running round our chalet hawks hedgehogs nightingales frogs dogs & the german for *'badger'* sounds like *'ducks'* fine as fuck nice evening more bier.

from the balcony i watch boys take part in the machinery of movement, learning to skid their bikes backwards on pavement laffing & pretending to crash into each other. street lites flicker white to amber to black. dark streets lit by youthful buzzing luminoes. the only difference between here & cwmbran, cardiff, plymouth: the trolleys here stay parked in their line instead of inhabiting trees & canals & brook banks.

we get back to the chalet, stone it up on a stash of incredible super skunk scored via the jock rangers fan & his mate. they led our legs on a treasure trail with that old fave: *"i know a place..."* without knowing fuckall. but we get some anyhow. drove thru a town & under a bridge & parked up having given him our money, tapping the wheel waiting for him to come back a police car drives past & gives us a look. it's a small town, one of the sound crew saw us by chance & parked up, tapped on the window sending me thru the roof. *"hey boys what are you doing here?"* uh, nothing man. just giving a guy a lift, see you later yeh. the jock comes back, had to give him a bollocking for shouting abuse at german girls as we drove back

47

out of town. man, shut the fuck up! *"why, they don't know who we are, who gives a fuck"* cos i do you dull twat, the name of the band's written in huge fucking letters down the side of the van. gobby jock cunt if he had a brain he'd be dangerous.

but he did get us this skunk. we have five shining skin-ups of green budding as we each open up & inhale, gasp admiringly & crumble more into more skins. five smokes coming up please thank you danke bitte schön tschüß *prost!* & tidy nice one. bier & laffs & smoking & prediction whist til seven in the morning.

waiting. everyone's gone to bed but i'm still up even tho i'm due an early to erfurt, a band trip to a music shop to stock up on supplies then potter about in museums, up the steps, the cathedral, shops & bars. band trip my arse, our guide had said earlier:

"hey boys, you wanna go to the music shop yeh?"

(the band: *yeh! - music shop! - too right - yeh! - get on then...*)

"you wanna go yeh? & you wanna go yeh? so everyone wanna go yeh?"

(*yeh! yeh! yeh!*)

"ok i will see you all here eight o'clock tomorrow morning..."

silence from all parties. the guide took it as a yes. slowly, throughout the evening, the boys come out with their excuses:

"uh listen, i might stay here tomorrow, i've gotta do some rehearsing..."

"i've got a new song that needs finishing..."

"i promised i'd meet this uh, uh, this person..."

we all know too well we just can't get out of bed in the morning but someone's gotta meet the obligation. me & the bassman take it on the chin & volunteer, knowing we'll be better for the trip, out of this fart-riddled chalet.

"well if you're going make sure you get me some strings..."

blim badgerers the lot of us, we're all too used to working the nite shift.

barbecue in the sun & lake fishing with various east german families. eating thüringer rostbrätel we & the locals are socialising. school teachers, social workers, frank zappa fanatics, poets, musicians; us, 30-somethings, children. eager ones fishing & repeatedly kicking the ball in the water. i've hardly touched my bier. getting into this book; reading examining cain's designs for text placement & other wonderful typography. make notes & scan transfers. one of our hosts good enough to photocopy some of it in his lunch hour.

sat in a tree at 7:53 watching the sun at 40 degrees from the water. the others sat below on picnic cloths, eating, talking, kicking the ball or spinning the reels, catching seven inch rot feder (red feather; red on two fins & edge of tail). i'm trying not to think about yesterday's score - the city going down 3-2 in the playoffs to northampton fucking town of all people.

twelve feet up in the bifurcation of this tree. i climb as the sun shines down on me, reach solitude while remaining communal. a friend of the band, the poet from wales - they describe me, then try & explain wales, unsuccessfully. i sit in my tree & observe the communicating of shared meals. low conversation

& high experience. sex & drugs & rock'n'roll meets the german family outing. weird. but beautiful.

our host takes dickie guitar to the doctor's. his arm may be broken (his neck could be broken if you believed all the moaning) but probably just swollen & sore as fuck. bad luck but what can you expect if you slip playing keepy-up in a thunderstorm under trees outside the chalet at six in the morning. pissing it up, he decides to take the ball out for a kick about, burn up some energy, slips & cracks his elbow on the corner of a breezeblock, the bier in his hand smashed & cut his strumming mitt. still carrying the neck of the bottle he trails bier & blood around the corner to howl in private, away from the school girls who were plying their attentions, intentions, hashish, alcohol & promises of more than flirtation in return for tapes, autographed posters, the attention of older men. they wrestle for position amongst themselves. we behave ourselves.

we were having a drink. answered the door to a bundle of girls who asked to come in. got joined by turkish camp staff. the school crew on holiday, were nice but kinda young, we had trouble distinguishing their age but were glad of the company. held an impromptu band meeting & reckoned they were jailbait pure & simple. tempting, beautiful, flattering even, but none of us wanted to spend summer in an ex-stasi prison. they asked what we did, what we played. i was explained as the band poet from wales:

"you are not from england?"

no. he is from wales.

"wales?"

yes. wales. cardiff.

"cardiff?"

yes cardiff. you know ryan giggs yeh...?

"no, i cannot be expected to know every little village in britain".

ryan giggs the little known village. cracking.

we smoke & drank in friendly conversation. they took addresses & fotos. slowly disintegrated dissipated disappeared & drifted. next morning guitar boy's elbow sore & swollen; the tour into jeopardy, we're threatened with an early return to britain.

from the tree i read a map of catkins & algae & reed. i've been singing in my mind the whole time the jam's *'tales from the riverbank'*. dickie comes back. his arm is fractured. fuck knows how he'll play the guitar tomorrow or for the rest of the tour. star performance. we have scored an own goal.

i swig from my bottle. flat liquid. ducks fly green-necked overhead. a volley of rifles not too far away. i duck down in case. perhaps a red army border patrol, lost in time & space.

★

i drink & read *'sexus'* during the schalkau gig. sell tapes to no one cos the crowd are all listening to the band in the main space. *whose dozy idea was it anyway to put me in the corridor?* (the band's probably, *bastards!*) crowd? crowd!? we find out most of the locals are down the road at a tractor-pull.

the owner speaks no english. we speak little deutsch but understand the language of a constant supply of free jegermeister all round. down em in one, he's insistent. i sit

reading *'sexus'*. get told how it was a favourite book in the old days behind the curtain. i smile to confirm our mutual good taste, his smile tells me he thinks i'm a pervert.

i hover in the doorway, listen to the band & watch people dancing. a woman leaves the bar & comes to examine the merchandise. we get chatting, she buys a tape, scribbles an address & demands a postcard from wales. the band have encored & finished their set. she kisses me & i serve the rest, pocket cash for the band, pack up, gather cables, pull up gaffer tape.

we get stopped on the way home. slam anchors at a road block & a van load of coppers wave handguns shine torches thru our windows - *"documents ja!"* - their police women so much better looking than our own. i'm stuffing the stash down the crack of the settee in the back of van. they check our paperwork. we get sent on our way, we ain't who they're looking for. i'm up to my elbows tryna drag out the stash but it's *fuck knows! FUCK KNOWS!!! where's i' gone? WHERE ZI GONE!!!* spent most of the journey tracking it down, finding it, clinging to it, promising i'll never let it out of my sight again.

dickie tells the story of getting stopped in belgium: pulls the van into a service station, calmly pumps petrol when suddenly he's flanked by armed police in conflict stance. he stops pumping gas, understandably. guns cocked, they've got him assuming the position up against the van. they check him out (mistaken i.d), he's shaken up, they make no apologies. he fucking hates belgium even now.

★

gig at the pub on the hill, between sömmerda & weißensee, just a couple of miles from the chalet. my turn to drive. easy. there's an outdoor stage so a piece of piss to unload, set up, do

the show & get out of here.

we play to a satdee nite crowd & they're happy. even this

HHHUGE!

fat bleeder's dancing. no one can get near him but he's dancing. we get fed well between sets, hit the schwarz bier & braugold. couple of the boys chat up the bargirls, it's a quality joint. i take fotos, sell posters, the band do their job well against the acoustics of open air, hot threats of downpour & the sweat turns to cool air soon as the lites get downed after encores. we drink & talk & play interesting aliens for a while. then unplug, coil up, foamhug & flightcase ready to go. goose about with the sound crew who call me over:

"welshman! welshman come here, we need you. come here... now shut your mouth, the shit will get cold! ha ha ha!"

& the band & the sound crew & everyone else laffs. i laff. the ease with which the germans take the piss, in english, is impressive yet unnerving. we take our turns to be butt of the jokes... i'll get him back goodstyle tomorrow.

the sound boys do a great job. just have to remind them once or twice: more bass. we leave in separate vans our separate ways. them back to sömmerda, us back to weißensee. we climb in the van, two of the band decide to rave it up with the bar staff. they see me back as i reverse to turn round & straight into fuck shit that was loud. my navigators have disappeared. i stick her in first & move out, brake & jump out to see what's happening; to see i'd rammed back into fuckoff great cattle bars on the front of a 4x4 vehicle, all big tyres & chrome shine scratched & dented. ok boys, in the van fast.

"robbo man ju know who's jeep that was?"

don't tell me, don't care, don't tell me, don't care, get out of here, shut the door, come on shut the door man! less go!

"it was that giant looking geezer, the biggest man in europe had to be, thirty stone at least man!"

course it was but i doan wanna know, doan tell me, doan wanna, didn need to know thanks lads thanks a bundle, jus keep ya bleedin eyes open while i swing this cow homeward.

"he! he! he!"

yeh funny boys right, funny as... just wanna get outa sight before that huge cunt finds out.

"i'm telling you robbo, fucking funny, the look on your face man, fucking funny!"

i'm being practical...

"should've seen your face just then! honest right, it belongs to that giant great seven foot thirty stoner we saw in the pub"

"he! he!"

"he! he!"

(all three of em are having a laff)

"the look on your face!"

yeh thank you, i'm tryna drive...

"it's ok though man, he'll never know it was us"

"never know it was you who smacked fuck out of his truck"

"he! he!"

"he! he!"

"don't think he came out of the pub"

"fucking face man!..."

"he! he!"

"fucking laff!?"

yeh right, for you bunch of cunts...

"gotta laff man, robbo: gotta laff"

yeh yeh, i am...

i can see him now, coming out & saying in german like:

"who the fuck! who fuckt my wagon!? who fuckt my wagon!?"

can't see him having too much of a laff...

"he! he!"

"he! he!"

"he! he!"

the boys won't leave it so i feels a right twat...

JINX GUNNER
NIGHT INTRUDER

THE HIT-MAN

YELLOW STREAK
VANISHING TRICK
THE WHITE FLAG

HOODOO!
FRAME-UP
MORGAN'S LAST CHANCE

HERO IN A HURRY
WAY OF THE WARRIOR
LEAVE HIM BEHIND!

"don't worry man, it was just bad luck".

we're out of sight. get back to the chalet & roll one right up. settle back to a few hours of german telly, munchies, settee-wide discussions on the evenings best happenings & women & laffs. remember the two of our number who're out there somewhere raving it up:

"however hard they try, there's no way those two bastards'll be getting a shag tonight"

three o'clock:

"so what time's the clubs close round here then?"

four o'clock:

"there is just no way, no way those two ugly bastards could've pulled women, like real women"

five o'clock:

"they've probably found a party"

five thirty:

"bastards! those ugly jammy bastards, they must've must've got lucky!"

six o'clock:

"they're getting it, right now! they gotta be! fuckinell!"

six thirty:

"they could be in custody. yeh that's it, they're in custody!"

(a communal: *thank fuck for that!*)

seven o'clock:

"nah, i can't help buh think those two cunts've gone & got it together with somebody some couple a german women... fuckinell, i'm gonna bed then. iss all they're gonna talk about when they get back here, i'm not staying up to listen..."

"should've gone with em..."

withem... women. fuck.

we've all crasht out. i'm in me pit; on the foldout settee. the two boys come back & raid the kitchen cupboards at the end of the room. stoned to shit.

THE TWO WHO GOT AWAY

laffing to fuck & tryna be quiet. i'm asleep, was asleep, in the all-in-one kitchen & lounge. a hot nite so i've zipped me bag

57

down. i've got me knob hanging out cos like i said, it's a hot nite. they've grabbed me camera, i get kickt about:

"jusss took a snap of ya cock mate... that'll give the girls in jessops something to laff about..."

yeh right, nice one lads, one of those nites, good to have you boys back in the fold you bunch of chopsy shitfaced twats, just what i need right now: a fuckin double act.

"robbo man, been to this party ina concrete bunker ina middle of a field. bizarre! this fuckin weed they give us..."

did you get a shag?

"shag? shag!? no fuckin way this weed they give us... could ardly speak... but like i say this party..."

bring any back with you?

"we did buh like we been walkin fuh weeks up hills thru fields of fields of rape bright yellow rape pretty trippy fields man i'm tellin you like really yellowy really fuckin yellow, incredible..."

so none left then?

"no man, we tried buh we couldn'..."

you selfish cocksuckers, me & the boys've been worried sick about you, thought you might've been arrested, murdered, we've been expecting the authorities to turn up, you don't know what you've put us through you ungrateful cunts...

"sorry man, we've been busy tryna concentrate on walking..."

fuckem. enuf of that. if they ain't got no weed i ain't fuckin

listening. at least they didn't get success to taunt us with.

i pull me bag up. back to sleep & dreams of frau if these two stoned fuckpots'll shut the fuck up for two minutes, giggling fucking dipshits i mean i ask you yur we are on a cultural fuckin mission reduced to brits on the razz, i mean: grow up (literal translation: invite me next time). i roll over, they piss in the sink & retire.

get woken at one in the afternoon by bassman making breakfast. armies of ants & big german blokes in ill-fitting shorts all over the campsite. dreams are still fresh in me, of tea & buttered toast made from cheap white bread & sal asleep in our bed at home. the torn hole as i wake alone is savage.

i get out of the shower. dry off, get dressed. stride through the sunshine, the chalet park, the *'carry on'* film waiting to stage itself. the band have stirred. somebody hands me my first bier, i raise it to our neighbours sat on their porch & *"prost!"* to them. they, barely dressed & scarlet-chested middle-aged germans, smile in reply. the wife, presumably, raises a half empty bottle of vodka & laughs manically. *'carry on the piss'* now screening.

the germans arrive, we've been invited to a barbecue in jena. they lead in their mega mini van, i drive the bandmobile. half the band are in with them so there's no need to discuss who gets the front seats. we reach jena. drive through the town & get within yards of our destination. i gota stop fast at a junction, slam on the brakes, wait for the lights. we're sat on an old rail line. the traffic moves off. i put my foot down on the clutch & prepare to slip her into first. the gearbox freezes seizes & refuses to move out of neutral. i look out me side window & see a tram steam towards us, hear its siren horn &

the face of the driver getting ever nearer closer larger & the van not moving & i'm trying to explain to the boys sat next to me the urgency of the impending disaster tryna tell em that our lives are in danger that perhaps we should remove ourselves from the vehicle explain that i'm trying my best but the van won't shift tryna explain that if we do survive the van & the band's equipment packed in the back certainly won't tryna tell em that the curtain is closing the tour is over we are seconds fractions of time away from an electrified metal caterpillar exploding thru my door from each of us having our skulls compounded our brains squeezed out like a burst zit from getting crushed electrocuted & torn in half but all i can get out is *FUCK! FUCK! FUCK!* & the boys are giggling at me, one of them sez *"what's wrong now?"* like i'm throwing toys out me pram & all i can see that they can't is this tram not slowing down & i'm pushing i'm thrusting i'm demanding the gearstick to do its stuff but it refuses. my life flashes. that really happens. & views of old shakers stuck on railway crossings heroines roped to sleepers keystone cops & wheels falling off, black & white frames dubbed with organ music & thinking i should change my name to harold lloyd - come on van, *shift it! now!*

Oh Fuck!

the tram has brakes. they work. fortunately. but still only stops inches from the van. i climb out the passenger door. the boys push me towards the back & we push it off the line watched by passengers & the tram's sighing driver. late again, his

expression tells me what an arschloch i am.

we push the van some thirty yards to our destination. one of the boys comes over & gets in the driver seat. starts her up first time. puts it into first, second, third, fourth, reverse. *"robbo you dull fuck, whass the problem?"* that van hates me.

we meet our guide's sister & her husband. get fed a thousand different types of meat in an open space behind their apartment, overlooked by derelict stasi dormitories. great german sausages, pork chops, veal steaks, an onion relief but we're dying for a bit of veg greenery. *"come & see my reptiles"* the only break from eating. every so often one of the band looks at me & sniggers. i provide the day's slapstick, as usual.

we thank them for the food we eat & the huge mass of meat we leave; for their hospitality. it's not easy having foreigners for tea. two of the boys take the van to buy bier, the rest of us go with the germans. the van drives perfectly for them. instead they get pulled over by the police on the look out, checking traffic through binoculars. passports & paperwork then allowed to drive on. an all points alert an all cars call. the police scour the country for el bandito the fugitive the one they called the one-armed man. how they let dickie slip the net we'll never find out.

"let's go for a bier."

ok.

"i know a good place to go. it is, you would say, my local."

what's it called?

"i do not know. it has no name. it is just: where i go for a bier."

we walk into a little room in somebody's house. tables, a bar, a landlady & a beautiful barmaid. drinkers rap knuckles on tables when they leave or enter. we get introduced, drink our fill. biermats are collected & we pay our bill. business expenses. when we leave the barmaid gives us two greatbig ultrasweet cakes to eat at our leisure. so moist, so sweet, so gorgeous. the cakes weren't bad either. so gorgeous we woke the next morning to a line of ants from the door to the cupboard. we opened it & wished we hadn't. every ant in germany had invaded the cake. we took to calling it poland. that's unfair & uncalled for. we had no choice but to chuck it in the skip. we ate the other for breakfast.

in erfurt we're just about packed & ready to roll. the band lean out the van, talk to girls. i'm downing my drink & ready to join em. two punks sat next to me, the woman turns & hands me her spliff. sez *"i like what you did"* - i guested on vocal; got up on stage to rant over an instrumental. i drag it back, inhale deep, cheers, it's fun to get on stage with compadres. *"& i like your hat!"*. she's got crazy eyes & a number one skin. *"you must come with me, i'm going to keep you, i like you, you're freaky!"* uh, yeh right, little cough & hand back the spliff, who you calling freaky, have you looked at yourself? thanks all the same but i better be going, the band are leaving. *"it does not matter from now you will live with me"*. uh, sorry like i gota get back to our chalet. i check my route & stroll to the door, the boys are revving & waiting. jog to the van, climb towards the passenger seat, my feet off the floor the van starts accelerating the door swings. the drugged punk has followed me, grabs hold & sez *"you must stay with me!"* yeh right, in your dreams, get yourself some counselling. she lets go eventually & we drive off. the driver stops suddenly just a dozen yards on, the

band giggling like kids, *"you don't have to come tho lloyd, you can stay here... he! he!"* pops the horn to get her attention. i check the side mirror, *gott in himmel! mad skinhead woman!* put ya foot down ya bastard, the woman's either fruitcake or devil, either way i ain't sleeping with it. the last we see she's chasing the van out of erfurt.

★

last nite in germany, we leave weimar straight from the gig, drive to a village to say our tara's to the sound crew, at the junction we split. wooden crosses on the snake of the lanes lit by full moon & dipt beams. my shift at the wheel don't begin until calais so sleep in the back with my head over wheels, inches from tarmac & rubber bumping roadkill across half of europe. dreaming to the sound of the axle i've had more sleep on an all-nite vigil stopped trying by seven a.m, cracked out the remains of the cake we got given & breakfast on the autobahn. pissholes in the snow. the cake creates enthusiasm but there's not much desire for conversation on the way home.

dickie tanks it thru belgium, haunted by his previous fun & games with the local force. stop at a warehouse just before france for a cheap smoke fiesta, we'll make up some costs selling this lot in britain. *overload once more*.

catch the ferry, the *'pride of dover'*.

FIND THAT U-BOAT
THE SILENT SERVICE

the crossing as exciting as a soundcheck - i exaggerate, nothing can match a soundcheck for boredom. dutyfree shopping. stuff ourselves with egg & chips. first sight of britain...

OUTCAST ISLAND
BLOOD BEACH

HOOK, LINE & SINKER
THE ISLAND OF GUILT

gota reset my norm to drive this side the street; wind back my watch; drink piss beer.

welcome home lads from our euro adventure. nothing expected of us, remember we're just a bunch of dole queue nobodies here. but we're better than how they frame us...

a manhattan montage

▶

i walked from 34th & 8th to 14th & 1st because of a bomb scare, the weight of my bag of books screamed beer beer beer

i saw firehouses adorned with flowers & toy tenders; messages of love, grief, fear

in the subway i took a token, scratched an extra word so it would read GOOD FOR ONE SO FARE & slipt it in the slot; heard a man in blue blazer, red tie, windsor knot, lapping the platform spouting hard *"i'm squared off! i do not want my currrrve turning into a circle, so fuck you fuck you all!"* - oration, sermon or thinking outloud. i caught the express & deserted the rant, the rats & the embarrassed crowd

i took the A train & L train, ate with painters & jazzmen, drank brooklyn pilsner at the brooklyn alehouse listening to blondie, got flashed by a police car in an empty lot where the east river meets north 5th street, guarding a subway airway against chemical or biological terrorism, it felt like a dodgy drugs deal to me

swapped a book & two bottles for conversation & food off polish bedford avenue, discussed fire or flight, the shanksville plane, the brooklyn queens expressway, space & time, slow action in producing speedy looking results, punctuation in painting. ate orange roughie

at penn station i received a red-white-blue ribbon & a leaflet explaining how sikhs are not muslims; i took fotos of MISSING posters & commemorative flags, spent the nite hunting a shop i'd seen earlier, a notice in its window read GAS MASKS IN STOCK - LIMITED SUPPLIES, BUY NOW! i asked the many police patrols, each replied bluntly *"there's no need for masks so no shop selling them"*, but there was

i watched the DN truck unload the morning papers at 4am, taxi traffic rife. at the kerbside outside my hotel a driver slept at the wheel of his limo, alongside a streetsleeper slept at his cart. a handset swung from a payphone, i finished my hot dog & put it back

flags everywhere; stars & stripes & irish tricolours & my little red dragon badge

their coins worth nothing except to the trash

$

i ate breakfast at lindy's. once.

drank tea in the lounge of the algonquin hotel, *alGONquin?* the doorman pronounced *"algonQUIN"* which is twice as fast; i drank tea & dreamt of going down on jennifer jason leigh dressed as dorothy parker, i drifted on this for a while

outside the library we laffed at lions wearing big & black NYC baseball caps. went inside & read the handwriting of lincoln, roosevelt, jefferson, signatures of tolstoy & trotsky, welsh names on the declaration of independence, a scribbled presidential note (woken at nite by the invasion of poland), handwritten drafts of the declaration of rights & constitution of the state of virginia, the louisiana purchase treaty, the emancipation proclamation written with a firm resolve, JFK's

speech should armstrong & aldrin have been stranded; actual
& alternative histories for us all

a self-published copy of edgar alan poe's 'tamerlane & other
poems' BY A BOSTONIAN 18-years-old; the 24-part first
edition of william makepeace thackeray's 'the virginians' & a
page from the writer's own

brushstrokes by the officer-artist thomas davies: 'the 1776
attack against fort washington & the rebel redouts by the
british & hessian brigades', also 'the landing of the british
forces in the jerseys'; attacks on the highground where now
sits the city university of new york, or CUNY, *coo-nee*, cunnies
& coneys cunnies & coneys - i remind myself of the word's
euphemistic meaning; the paint reveals the battle of harlem
heights, the british frigate 'pearl' counterpointing the navy

we welsh writers read at CUNY; at harlem we represented our
country & pounded the battlesite with prose & poetry; they
responded, with shy applause, email addresses, rough drafts &
probing

UKinNY banners flappt up & down broadway

we passt old men on folding chairs listening to BIG
soundsystems in little cars with every door open, blasting the
street with sweet hot music from cuba

i swapped smiles with mexican waitresses, admired as they
made for me fresh guacamole & poured my corona

felt that funky subway heat, crossed 110th street, found out
the meaning of 'fink'

saw a woman look up at the sky & watch a faraway far
rockaway aeroplane fly towards an office block, but behind it.

she looked, so everyone looked; waited for it to appear on the other side. i watched them wait, prevented by spikes from resting on a siamese hydrant, i saw them sigh then turn away

smelt the blast of grass as someone passt on the sidewalk, my senses went walkabout without me, it smelt *fffffresh*, the first since i'd been here

everything else in new york city smelt so sweet. i sought it out & found it resided at street corners & subway entrances: the sticky sickly sweet aroma of the roastnut vending carts. we duckt in the broadway dive & ordered a round, they'd swept up the peanut shells

at st. agnes library we listened to four thousand poets read four thousand hours without mercy. trappt in the front row, hot & sticky & numb, i saw visions & hallucinations of chinese junks, ageing faces, aircraft, high rise buildings & tensile bridges in the grain of the stage floor. tuned to the traffic sound from amsterdam avenue below. considered the business on the otherside: burritoville & EJ's luncheonette, between them the silk road palace chinese restaurant. i'd like to be there, at any of them, listening to the montage of conversation & food orders & differing voices & tones & secrets & jokes & looks. further along: antonio's barber shop - this sticky humidity, it's not a town for long locks

we heard poems of september 11th & arguments amongst these writers over whether they should be writing such things; we heard pomposity & stanzas of slush. but we heard good words too & this turned our luck

eventually, beautifully, poets were evicted by library staff wearing urban camouflage. we hit the racoon lodge & a million & one irish bars; i saw new york thru the bottom of a beer glass in irish bars throughout the city, statuettes of gerry adams &

ian paisley had me wondering where i was putting my money

we drank samuel adams boston lager, INTERNATIONALLY RECOGNISED AS THE BEST BEER IN AMERICA; i drank sam adams for fifteen straight hours at five dollars a glass with an ecuadorean virginian studying at princeton - between us we drank sam under the table, we were still standing but new york city was on its fat ass

she told me of her lives in virginia, jerusalem & florence; we discussed hebron & the occupied territories, family & love & loss; discussed writing & literature & language, i sold the semicolon but she's comma happy; she allowed me to sprawl shambolic conversation in her direction, showed me how to write my name in hebrew, we defined jerusalem as the bellybutton of the planet & giggled & spluttered & coughed. at five in the morning we ran out of bars

$

i met at grand central a woman by chance; a random expat who went to school with my mother. i askt: compare brooklyn to tremorfa. she can't

took afternoon drinks at the manhattan bistro with poets & journalists; read with renaissance junkies, mexican kerouacs, the laureate of brooklyn, slam & subtle pioneers. met black poets who put down the anthrax to internal white supremacists; collagists & well legs in plaster casts of their own making

i went looking for directions & found reclining in a basement a big ginger nude woman, on spring street. sat warm in raymond's cafe open onto 7th, watched the world walking dogs & pulling cabs; ate medium-rare lamb with peas, carrots, mustard gravy, mash (meat & mash a new york favourite, a

plate of veg a rarity)

hunted unmarked galleries promising typographical expertise, found musical scores & thousands of tiny burn hole waves crashing on pink graph paper shores, indented grey cardboard opposing braille, waxy crayon combed to leave patterns in crimson... spoiled by typex-ridden typewritten claims of new language; communication imprecisions, good looking mutes & visual dysfluents

we joined the audience at the ricki lake show to add range to experience; sat & listened to america's sad virgin teenagers claim authentic vampiric tendencies. mothers screamed at sons' first girlfriends then sat & chat thru intermissions. we clapped on demand, they on stage: too much or not enough menstruous experience

saw scarface shot up by a cymraeg stormtrooper, performed magnificently; a spiral of brazilian art at the guggenheim museum, 'dialogue with ghosts' & 'concretion', everything dated pre-20th century depicted oppressive icons of religion

in a bar at the pale of the village i got taught by a poet her family sayings & drinking phrases: *"when you're in the kitchen drinking tea, burn your lips & think of me"*. resurgent, energetic & glowing, allergic to dust mites & this crampt little bar we're in, she has cats, a strong book & a shoebox in brooklyn. *"lechaim"* (a phlegmy CH & a rhyme with 'time'), i *"lechaim"* each time we get a round in. we hugged at the subway & new york begat a new friendship

attended regularly the fat black pussycat opposite the blue note, sat in their opulent chairs drinking cheap beer & hugely mad chocolate martinis & got down to the room spin. in the rest room: EMPLOYEES & DART PLAYERS MUST WASH THEIR HANDS, but only in the women's. in the other: two

men, one berating: *"you do not disrespect the woman, if she threatens your manhood you ain't half the man you claim to be"*, both dressed as halloween wizards

saturday night in a busy bar & not one cheap british suit to get chippy, but there are too many t-shirts in this city: stars & stripes & bin laden noosed, DEAD NOT ALIVE, NOW IT'S OUR TURN, fighter jets aimed at minarets; blood hunger, fire power, tall buildings

i bought an enormous pizza from an allnite deli, took it back to my room at the pennsylvania, almost got arrested for taking fotos of their chandelier: hidden cameras in surveillance glass. gave two slices to the security guard for letting me pass. got stuck in an elevator. ate my pizza & contemplated the paranoia of NYC. got back to my room & hit the rum. passt out in front of the tv...

$

i rose from the subway, some guy dressed in combat gear hands out leaflets advertising authentic uniforms, kids camo's, dog tags, insignia

we ate mushroom & barley soup outside café centosette; vegetable special at the kiev on 2nd; drank bass & jever at the BRITISH-STYLE telephone bar with its row of red phone boxes, the yanks ordered shepherd's pie, the brits ordered burgers. at gioia pizza i drank birra moretti & ate anchovy slice, spoke with the italian staff: *"how is wales?"* - you know wales? - *"sure, the drrrrrragggggg-onnn your badge, iss nice"* - wow, an american who's heard of my country - *"no, not american, new york italian, ciao, have a safe flight"*

at st. mark's i read way past midnite; felt a small earthquake & dismissed it as the subway. read about the next day, felt the

city shake twice

drank at the scratcher deep into the nite, surrounded by london boys drunkenly dancing, they stopt only to coax our company away but women can make up their own minds. the boys danced amongst themselves, as if they hadn't askt

this city a sensorial onslaught & delight but i'd hate to be poor here more than anywhere else

$

ground zero, as we moved south down broadway, revealed itself

i saw wreaths & single flowers tied to scaffolding, children's drawings & worldwide flags, stall after stall selling peanuts, baseball caps, framed photographs; thousands of people dressed in black treating this memorial day as the funeral for loved ones missing or found; a clear blue october sky

there were people crying on each other's shoulders, there were lenses pointed upward

i watched news crews battle with trolleys of equipment, satellite link-ups, each other, locals, mourners, tourists with disposable cameras & snapping tempers... the best angle blocked by an empty police bus

read quotes from the bible pinned to the barriers, heard preachers grab their chance for an audience *"if you hear my words then you are my disciples indeed & ye shall know the truth & the truth shall make you free"*. a banner outside thompson financial proclaimed THERE ARE PEOPLE LOSING MONEY AT THIS MOMENT

i felt the chemical volcanic smell hit people in waves

heard generators of emotion & electricity; a woman scream *"you fuckers don't know nutin about the world trade centre!"* another declare *"i worked in that building!"*. the policeline discussed the yankees' world series & received proposals from starstruck young women

saw debris from dey street, water cannon, cranes & hard hats, redcross & firefighters, an upstate trooper replace her face mask & zip herself up, wreckage & remains, a black veil blocking reflections in the windows of the buildings opposite, birds circling, going haywire amongst the wet mist

an empty block fenced between cedar & liberty, felt the temperature rise by the time we reached pine street & the crowds had vanished by trinity cemetery. the bells of the church broke thru the gorgeous fall sunshine which itself broke each block onto wall street

heard the growl of the reopened subway

under the gaze of the american express eagle, a billboard for the citigroup advised we LIVE RICHLY

saw government vehicles flanked by sirens & lights blaze up broadway, read plaques on poles IN HONOUR OF THE REMOVAL OF THE LAST BRITISH FLAG IN THE COLONIES... IN THE 200 YEARS SINCE THE BRITISH HAVE BECOME OUR STRONGEST ALLIES, stood under a statue of immigrants kneeling & weeping & rejoicing

then, at 2 o'clock, press helicopters interrupted the silent prayers of those they were filming

$

on the long island expressway we passed jamie's collision &
repair, shea stadium, exits to jamaica & queens. the radio
informed us the IRA had been instructed to disarm by sein fein,
the bridge signs warned all to AVOID LOWER MANHATTAN,
the plates claimed THE EMPIRE STATE. i paid the taxi fare, toll
& tip

at JFK i took fotos of a luggage trolley proclaiming WELCOME
TO NEW YORK while behind it read WORLDWIDE MONEY
clarified by a currency stall

a beer in the concourse. i read as i sat the poets of the city &
they drove me to write more than i drank

a hotdog cart sold HEBREW NATIONAL brand beef franks, its
red & yellow umbrella offered the sales pitch of WE ANSWER
TO A HIGHER AUTHORITY. mustard on that god perhaps?

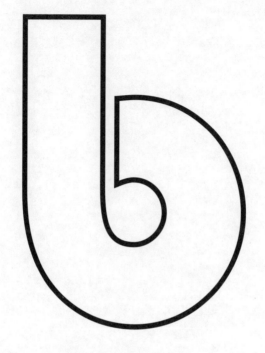

i can

see you

i can
see you

dreams of to say

(in my cast of dreams)

enter a society where any two beings meet speak
state his name his name her name her name his her their name
our name
the first goes first the other responds

"yes, i am (you) also"

they agree.

every remark agreed in total
no deviant meaning sound nor tempo
we try to speak but only greet whatever we say comes back
immaculate & immediate; clearer than it left us.

everyone has different names, statements to proclaim

"i am (you) also"

& we say them over & over to ourselves but still remain the
truth we hear is

"(you) also".

they say their names but all we hear all i hear is
what we put out come back the same refrain from multiangles
for everyone: exact transmission.
our own name.
we do not hear me nor anyone else
only the bounce of ourselves

we meet to communicate receive in exchange
exact agreement statement meaning sound tempo name

"yes?"

compulsive. you think we would learn to silence complain
censor ourselves or rally against
but we cannot stop our obsessive introduction
eager to exchange the introduction of someone else
the introduction of ourselves
we've met we've met
please go away.

there is hint of escape:
the name for ALL of us changes every time a new force joins
us.

there is hint of a catch:
("also")

only this new him or her ever gets to hear their name.

for all of us:
new meaning sound tempo will never pass our lips
but you will hear echoes of yourself from everyone else & we
will hear only
ourselves

we are prismbound, boundless in our will to escape
a smile on our face

 "hello, my name is"

"(you) also"

exchange.

change me into someone else.
the force of the constant face of myself
threatens to refract & reverberate.
contrast come shatter yourself.
hear me proclaim i am
not who you think
i am, i am

"(you) also"

strained & threatening to wake

"you also"

we say.

justa little

emotional
adventure

amusement●
experience

happening

"when man begins to permit himself full expression,
when he can express himself without fear of
ridicule, ostracism or persecution,
the first thing he will do
will be to pour out
his love"

henry miller - sexus

hundred hour love affair without touching nor stating just
flirting brushglancing buzzing & smiling
lingermo eyeballing
& now it's all over & i've nothing to show for
but feelings

of amputate missing.

i have done
nothing wrong
nothing by the laws of gods woman man nor
modern relationships wrong but i connected with another
which was good for my soul & now
needing

& it's gone.

& now i do not know
& in a week or so's will believe i was wrong to ever think
it mutual but i know it was
&
it was cool
& we both knew what was blowing thru
both in relationships of dedication & long view
but cannot deny our
natural instinct
instantaneous attractions
& itching

&

it was there.

it was there & we were open but already in love each other had
someone
so we better not better

it was there.

it's said you can't love more than one by one
but i've discovered found out it can still be done
just with questionable success
without
longevity trust
& it don't
doan make my life any easier to have uncovered a potential for
double love however brief it comes
it don't make my life any easy but fuck
what a buzz
what dilemmarous love
what cleaving

i've discovered it don't amount to a loss of the original love
the great belief undone
in the physical world:

we did nothing

no fluid exchange no talk of feelings
but encouraged & flirted incredulously
we were lovers in our eyes & in sleeping
tho this just communicated within public meetings
meaning
encounters by the minute
with a secret language of eye moves & gestures & beaming

we were potential!

we were open & took part in a long weekend dabble tho

nothing happened

no stolen kiss no icky neck no not in public no slip me a length

no love lick go down & do it do it do it again
again

no situations no lasting memory
no relive remember no supersensory
justa jism glint mirror
in the eye of another
suggesting
so many feelings

i fell for her big time. clearly.

& once she put her hands on my cheeks & as if to kiss me full
on the lips
but said my name & walked away & this is as this is as close as
we came
to docking physically.

maybe the lite
maybe adventure
maybe the constant shared single-skinners & shroom booze
cocktails
&
giggles in corner

maybe desire

maybe a call
maybe new fire

but our eyes were wide open & fucking
our minds not fucking but mutual immersion & emersion
were potential

were love umbra / pen um bracing potentials

potential fora brave new vista
after worldwide destruct emote demolition
the excitement of pressing the button
without any intention of inserting
the key

playing games of emotion

opening

would either agreed.

…

i feel sad

i believe in my instincts

my most intense most successful rewarding tumultuous
relationships
have been decided in that first half glimmer of eye intro instant

that contact

the rest until now have been uniformmmusement
mere candy.

it is over.
i miss you already.

misst you the minute i / doubt we will ever
in the same condition
so thank you
thank

you'll remain a lifelong vision a pleasure tradition

a love hit treasure
i dig you
dig you up at my leisure
to remember the backache & blisters the memorytwisters can't
get a hold of

we will sleep together forever for an instant
for as long as i can still remember
the rise of your breasts when no one listened
the rise of your eyes when we saw for that instant
our mutual desire
our mutual commitments
would deny us our influx our infectious intentions
our virus of new love
our new beginnings
&
glory be to the buzz!
you have enriched my existence
i thank you thank cannot thank you enough
now we're distance.

...

i am happy to partake without threat to my lover.

i have gained new experience.

i have gathered lost & felt the intensity of losing a lover
the potential for lover
while keeping another the actual in picture

in such a short space of time

my soul needs calm to acclimatise

...

all or nothing.

all or nothing i will forget her come summer except i want
do not want to forget the dilemma of tree love vee seed love
of better or better.

choices choices i have choosen & have chosen correctly.

i despair finish with lover even when nothing
despair making choices even when loving

i do not hate anything at this moment yet feel
the isolated state of unfulfilled & frustration not sharing then
now never i dispose of a potential future
regret not experience the YOU adventure

maybe another day another life another pleasure
in greater detail
at our leisure.

it will have to be

i do not intend losing what's cost me already for she is worth
she is worth everything

but sacrifice means pain & that's what i'm feeling.

> *would she*
> *understand this a good thing?*
> *or should i keep this confession for deathbeds*
> *& neverborn children?*

i have made my decision.

she has made her decision.

if either one or the other had said it might've been different
we shall never know.

 the sadness of unfulfilled yet requited potential
 the sadness of mutual untaken options
 acknowledge denial

i fall in love so easy am emotional

hunger for new experience tho happy know also
life's too short to miss out & too long to bad gamble.

i do not want to change my lovestyle.

am not in need do not have lack anything
look forward to deep delves into long love over many years
depths which i could not acquire except
after time & time trustful

but new life & desire for new people new highs
as well as do nothing to damage existing stoked love fires
that constantly burn existed exist & will go on existing
possibly til the end of our lifetimes.

 i do not want to transfer my pain to another it unnecessary
 vital she does not feel threatened
 life happens!

 but my feelings i aware of the integrit emotion
 am feel open then crush it's
 unlikely successful.

but what we know if nothing else
what we can learn about ourselves
we are still capable
of falling in love

with strangers with friends of friends with falling into friends
the potential for love
of inviting new friends & new lovers

& the way i feel both ript & relieved neither of us rockt the boat
tho requited complete

our stable coast our white horse foam gallops on
beautiful in distance. we got close & it nearly drowned us.
all hands lost no horn to warn us no flare to show us
no rope winch into & out of the deep wet nite
no helicopt saviours.

...

i am not a man without love
i am envied.

but i cannot have my cake & eat it do not want my cake & eat it
i want
love to love i do my love but the danger is to
keep in check
controlled
hidden
not hidden
driven

channelling potentials for

 my social tribe say i must love one at a time don't be greedy.

 but i am. of course.
 my life force demands on occasions periods stages
 demands in animal instinct

MY LIFE IS TOO SHORT!

life is too short & i cannot abide the pain of a lover shorn
of my undivided loyalty.

i have experienced it before.

i demand of her
& her equally.

 the door is bolted
 the prize mare untroubled uncolted by the
 hayrolling antics of the stable lad

 forward

 forward

...

i do not know the other woman but have
fleeting experience
 (worth trying

we could have might have made it
but we chose to continue what we already had going
& i'm

 suffering)

delighted.

imagine you
also.

...

it could've been difference.

probably the wise choice
certainly choice with the biggest return & least gamble
with stakes of big love & my turn at the table

> *do not risk what you have in the bank*
> *do not go out on a limb less you wanna lose your right hand*
> *do not cut down the trees you will have nowhere left to hide*
> *young man*

i should feel delight at passing this test but
bewilder unbalance disorientate & need of rest
&
soul restructuring
counting cost
marvelling at what i haven't lost & my
incredible found ability to not
fuck up again.

i have denied the opportunity to love
to protect the already love of my life
to protect & respect & honour the love of my living
but this is a lost opportunity.

i do not deny my choice

do not deny resent nor go back on my choice my choice
is a good one
but something happened
& now i am different

maybe reminded of previous existence.

would it have lasted?
i doubt it.

would it have been the best thing for her or me
i doubt never neither allowed it

the bitterness of our equal & mutual loss would eventually
have bitten
woulduv damned it

i have heard all before.

we would torture for years
brand each other's ears eyes emotions burn
with our sacrificial hot dropt potato of our current loves

but i
gave up for you!
you bassstud...

...

 maybe the mush draw endorphin diet had something ta do
 but i felt it i felt the
 potential for love
 & i cannot deny it requite it regret it
 but resent the not love not cake plate & eat it

 i masturbate to exorcise
 will eventually forget
 this feeling.

i am not a man without love it flows over above
abundance not enough
i want

& once tasted glut's hardly enough
especially if glut only instant

i want more & choose to withdraw when the chance rears
its wonderful head

choose not

knowing more equals less equals both lonely instead
eventual loveless & heartfelt fed with love mistreated
with hearts misbeating at the loss of it all

bush
bird in hand
the whole fucking emotional mountainous land

but i cannot have & it's unfair on me my loves potential
& everyone else

i did not ask
i was questioned.

did not ask but know
a part of my heart required a part of my human life required
this chance opportunity

i can still fall in love

feel love for a stranger without losing anything other than
our possible future
& that
i realise
cuts hard.

the option presents offers self up to us
the reaction the more than the sum of the rush

that secret ingredient that added spice
that little something extra
that mumbled excuse
myself recog acknowledged pondered & chose against

& now i know

i am still a loyal man

i have grown thru my loss.

i took the biggest hit off the bong & i should be grateful
chances come along to breathe afresh thru my other lung
tho i cough choke now it blew my mind
when i drew in breath & kept it
kept til i got home again.

it's happened once or twice before & i recognise now how
not to go & fuck it all fuck it up all over again.

…

to be shown the option

to be shown the option i'm unable to take is human existence
is shaking my chain
is choice making
& i have
 just realised

i have just this second realised i have proven something:

i have lost nothing from this except that i imagine
create
that which i never had in first place

YOU.

my feelings of being with you
my feelings of coming from you

the potential!

that charge spark i am sure you were aware of also

 (we danced private & naked)

stood clothed & in public
we stood next & so close & we felt
so you stood even closer

our actions were unison

that
all the proof i am needing.

i do not imagine dare not dream fathom
how you feel at this instant

wherever you are.
you are still with me.

i will get over this.
it was nothing.

justa
little emotional adventure amusement experience happening.

…

ten years earlier i would've grabbed it.

ten years earlier i couldn't handle relationships & these
ten years would've been baggaged with guilt feelings & blame.
i would've fuckt up again. put ya shirt on it.

gain & loss & loss & gain must remain positive
must stay flux imprisoned time time will one day allow it
some freedom to feel it as innocent as it really is
& not socially imposed guilt-ridden

i did nothing!
nothing!

just shared a vision of what could've been but but but isn't.

the grass is green the grass is green but this isn't this honest
sincere she blew my mind for the sake of a life instant
love emission mutual unintentional security breach
& it felt
ah believe me
it felt

FUCKING MAGNIFICENT

HHHEAT!!!

we bounced off it every waking flirting every sleep tossturn
instant we were near.

there was no
 fancy a drink?
no
 fancy a bit?

 no
 are you?

 i think i'm

 falling

i guess i could've imagined it didn't imagine none of this
surface? it was depth & dynamic.

none of this.

just social chitchat nothing showing no one nowhere
none than having laffs & fuckin glowing
but under this
& under that
& under surface of all of all of all of that
something of base substance

diamond tipt deep communication

 another life

 another love
 another time

 another distance
 another mine

none of that.

i already have & you already have & we read this
in each other's eyes

& i have & i'm more than happy with that with her
happy with her

love in love with her i love her so why
another *WHY WHY WHY*
when there are times i never once got a fucking chance
a sniff a sight
do i get the option now?

now unneeded not seeking
why present itself right at the time that my lovelife is feeding
why test me out so obvious & loud
such appealing potential
that's a dirty fucking trick if ever there was one
& how.

...

i love her.

 i lov loved love you for a while.

i doubt we will ever now meet will even speak
we exchanged no numbers knew the scene
don't even know our second names
nor anything other
than
how it feels to be
just to be sharing in each other's company

got carried away on the buzz

neither of us wants to fall in love
i'm sure of it.

a dirty trick.
tho i appreciate the option to partake
of a different sliver snippet scrape of living.

but it's proven

it's proven love's deworthed if it don't cost something
& crap tho it is complete clichéd bullshit
it's a part of my life this new
person
emotion
so
deal with it.

i will
get over this.

it was nothing.

justa
little emotional adventure amusement experience happening.

...

people envy those caught in the blast of emotion
but too much too much
each hit
what beautiful moments.

this is an exorcism.
most definitely an exorcism.

for backing out of adventure i'm disgusted

could be crying

could be but not
wouldn't know for what for the relief not endangering
the love of my lot or for losing what i do not
got have want

i want each love different
for the loss of the loss of *potential!*
being put on the spot
this exorcism

for a part of my being the rest cannot console yet.

i feel comedown.

feel comedown is ripping
cannot write cannot write this off nor put it down
as anything other than a crime with no clues & no victim.

i will never know for certain if she feels this
feels any similar
different.

…

i hope we'll meet

i hope we'll meet up some decades from now so i can
gauge today's feelings

finally close the file
archive along with the rest of them

or open them up
again with the rest of them

but for now you must leave me.

…

this is a love poem i suppose.

for the both of you.

i love what i know of you
but i love *you* more
i know it is so

but
for now

i dunno

what tomorrow
what *feelings*

...

living off lloyd street. full hot

i had been lucky. i called into the remainder shop in upper dock street on my way to meet the newport group & had bought myself a copy of iain sinclair's *'lights out for the territory'* plus other titles including *'american dreams'* by sapphire & a slim lee harwood at a pound a copy bargain quality tho not as bizarre as the shop in llandudno's mostyn street where you could buy your remaindered stock by the imperial pound weight. four copies of *'conductors of chaos'* for under a tenner - i gave them to the newport group told them to empty critical judgement don't take it all too seriously but open up some boundaries & enjoy it, they took them away.

'lights out' spent a week or two on my shelves of waiting paperbacks then jumped the queue. i needed a book that might develop my write-thinking & which i might enjoy absorbing. it saw me thru august; thru waiting at libraries community halls & leisure centres for no one to show up for my workshops. i facilitated the indifferent & unofficial teabreaks without them knowing nor realising. they were told but it didn't sink in. i was earning but it bored the arse offa me. demoralising. that was acknowledged by the organiser at our redirection meeting i mean it demoralised the both of us but for the cockney who showed up eventually at every workshop i did for about a month or six weeks every workshop at any rate every workshop with an attendancy. him. london. only punter i've ever known attend a poetry workshop in shorts, trainers, a tin of cider & a number one. jesus wants me for a sunbeam. he really got stuck into telling me the details of hoxton stoke newington the details of *his* root territory i realised he was telling of the same streets i had earlier been reading in *'lights out for the territory'* only this time in a full-on

london accent. lovely jubbly if ya likes ya cockney.

vallance road. i won't say no more cos one day he's gonna write this BIG book BIG novel about it based on it his life his family his londonscape & it will be so rich in culture & history in his territory having a copy on a frontroom shelf will be as london as double pie double mash double *licka* green gravy however it's written.

only geezer. chelsea supporter. grandad a boxer. wants to be good at poetry so he can apply his skills to his novel. i like that way of thinking. find it agrees with me. poetry as the furnace of apprenticeship for any writer who wants to produce quality & be good at it. this don't tell me much about *'lights out'* this coincidence but i told the geezer to buy a copy so he could learn from it & build ideas. maybe that was the reach. maybe the reason, or to continue developing my own writing about cardiff my capital & the beach.

it saw me thru august; thru rainstorms & workshops & a week laid on a greek island breaking into september, museums dedicated to their poets & ferry trips to olympia. i paused while a group of greek widows burst into song.

poet needa suntan too.

every time i go to greece i feel the need to write henry miller but never attempt so always fail & this relieves me. i disposed of his lifestyle ideas but their draw keeps recalling me. mediterranean temperature like the sweat of sex on a continuous basis. enjoy the heat. enjoy the cool of coming to contrast the grind heat. to be sat in the heat of the mediterrain like sex for the skin the pores the vocal chords brings out in me the outside in the show removed the hood the cowl the blind of british coverup too cold too pale makes me wanna sing silently listening to greek radio i love it i love it i love it.

writing on the bed in our studio on zakinthos; on a notepad made of old drafts spare scraps of *'cardiff cut'* & *'sissi'*. can't escape territory even here.

...

back in wales

i get paid to sit alone hour by hour in empty venues my files of workshop tasks my plan my dictionary my pens paper bottle of water & sit alone for hour after hour in empty halls waiting for the end of time from one end of the country to the other being paid anything up to well whatever to sit alone & wait alone & wait & waste when i could be home writing fotografting thrive & this they call a writer earning a living & my only survival is to overcome all attempts to bland me out to blend me in to take me out of quaranteen & so i have to believe in the value of my time in order to get thru this wasteful miasma of misdirected well-meant supply of possibilities for the disinterested blunder funded money shuffling well shuffle some to me & the only time this is recognised as wasted effort the only effort that's been put down to a complete negative is me & the poor fucka who organised it who's just tryna do a good thing & for chrissake we both need the money i can't write on crusts less you just want me to write how angry it makes me to be so eternally skint it's not thru choice no money does me in it's good of the organisers to be so positive just one of those non blame things.

but then you get just one guy or woman show up or a group's not forbidden eager & listen & then i earn my living my right to more time on this planet imbibing enthusing encouraging people to acclimatize to their own potential creativity & me pouring out my type & then the world is mine & i deserve to be considered a part of the plan & earn that fucking living. but then two months down the line still no cheque a few

phonecalls of spite *"not employing him again"* & i have to put up with this cos my doing workshops inexplicably makes me a better poet somehow. cos insteada writing i'm earning a living see makes a whole load of difference makes sense now doesn't it does it fuck as like.

no. give me time away from the stress of creating a living & my writing will break thru out of its prison & create a new trail. thirty day credit my arse i do my job right gimme my money you unreliable tightarsed no right get all this out before you dial this time no need to make more enemies than you have already but i did my part now you do yours: pay me on time.

...

the refrigerated water on the corner of the bath attracts condensation to the outside of the transparent ridged plastic of the bottle like to like extracts moisture from the atmosphere (check scientific fact) to coast its outsides & escape like to like escape its container its limits its strife even in bottled form water freeflows openform & moves as it likes like to like.

...

life is the showerhead. the fresh flush of pleasure & pressure set against my senses my head the flow downstream; down against & with my body. from the hair on my head the matting patterns my growth my mutancy my cracks & crevices. ridges of the showerbox the ridging of my skin; soles of my feet against porcelain. the cool water between these. the plugged hole. the hair blocking it. the crouching & thinking. moments of clarity. the shitting the bleeding the arse wiping. the hand shanking. the scented soapbars or multicultured coloured flavoured favoured pinefresh personal pumpaction hygiene. liquid easyclean. the continuance of fart action after it. the wet towel on the floor the piss plash next to the bowl the remnants

104

& skidmarks within it the durex in the bin the ill-fitting clothes the itching by the time it sets polished i could've rewritten the whole thing i change so fast life no longer represents who i've been nor whom i'm gonna be the best thing i've written tomorrow not yesterday the best i need telling the showerhead dripping the sides of the bottle condensing the cubicle steaming i gota get writing skin up stop quitting shut up.

...

our job as poets you might say is to cut to the core thru the crap. personally, in a round the houses kinda way. once attained this curves my existence i cannot switch off how i perceive the way in which we reside currently it haunts me all i see all i feel as i x-ray in & cut thru gloss is con trick & sales spiel & when i call perpetrator *cunt* they attempt to admonish diminish & discolour me. we still consider ourselves living as one putting each other into language isolation tanks the crowds come down like a ton of dust.

people know & choose to ignore consider themselves powerless they do not know do not like to be told we are all messengers so shoot me low. as a reaction to this as a survival device i turn the message to an arrow shaft & shoot at them first but this gets seen as aggressive. knowing i'll be hit by crowd volley i get shot down knowing at least one of em will be hit by chance by my choice burst others will bounce from my charm disarm their aim charm is a con whoever it's on a mirage to make you think you are wrong cannot see straight don't believe in it believe in i think i sometimes think like this shoot quick.

if i was rich i'd pay people to be honest open normal novel i would have no/not allow brave faces no banter false friendships no sales smiles nor diplomatic cases i would pay em up front to not attempt to make me part with a glib laff play the

game pretend to be entertained nor entertain nor. if they feel shit i would pay to hear about this shit of their lives who next they wish to punch out who they want to die young give me honesty & call me a cunt. bad tempered emotion every time. what can i do with it. at least then when you look into my eyes & laff & smile i can believe in that stop watching my back a moment my wallet my bag tell me your shit so i can believe in your smile & you mine. accept when i call you a greaseridden cocksucking bullscheisse cunt i mean it with love & sincerely when you say likewise & then when we say *you are the best thing to ever happen to me* we know we are right. we are the shit messengers shot this time. the message: truth or confusion, the rest outa line. everyone feel fine? great, shut the fuck up, don't make me say twice.

...

sex was often predatory. an early state of mind was

always looking for relationships & when i couldn't get relationships i settled for sex & treated women like jackfuck some of them used to it expected it others thought my inability to communicate or unwillingness odd & infuriating yet still acceptably disrespectful towards them. take it from my mouth. it was the women who wouldn't accept such treatment those who would not have anything to do with me those who were warned away who were of most interest the ones with whom i fell in love the most i sought the most i strived but even that was fullshit from the right way to do things i wish i realised that at the time but then i did & got meself sorted. nice one. about time. i wanted someone to respect & i found her. no one believed it would last.

...

'don't give me ultimatums or else!'. ha ha. my old man.

...

living off lloyd street, llandudno, 1999; living for just 48 hours

one afternoon pop down the plumes to watch wales vee samoa
had to ask at the stools:

> *"u showing the match?"*

barman sez:

> *"dunno yet"*

> *"well if you wanna tell me when you've decided
> i'll tell you when i want a pint"*

> *"what channel's it on?"*

automatic states (watching rugby in the pub)
cos i is welsh & i knows what i talk about.

industrial language
foul mouthed
not fit for ladies
wrap round pub chants

my friend kath calls me a cunt
& i don't mind
not like
she's calling me
a pussy
or anything

...

the gates to llandudno railway station remind me of buckenwald of all places. nothing deep here. actually reminds me of the gates to the camp & the cobble i nickt from blood road leading to it. poor when you think about it. same day we took the piss out of peter ustinov filming outside schiller's house in weimar. me wearing me big yellow cardiff city t-shirt or maybe the blue blimburnt replica top (let the world see, i wear the famous ccfc), i was missing the playoffs i remember that. nick standing in the middle of a statue of a big halfburied giant like he was his bespectacled cock. then asking the cameraman what channel we were gonna be on:

'i do not speak english. mr peter is busy.'

not the same day, the same visit. couldn't go anywhere after the barbedwire museum. the weather changed the minute we went thru the gates. *'jedem das seine'*. got worse when we went to the woods to consider the unmarked graves of germans killed by russians who after the americans had left continued camp activities. onto monuments & sunken graves.

took shots of gigantic statues & across the vale. exhausting. viewed the town another time. i drove the van down & three of

us pisst about in weimar. sat in the square & bumped into
ustinov. he was busy.

...

llandudno. away from the sea: the lifeboat station back at
rathbone passage. surely the only place in the world where the
lifeboat station is what six? seven? blocks from the saltwater
kerbstone & beach. i could drive there faster; i could get out of
the shower dress go downstairs go back upstairs cos i forgot
my carkeys i forget something everyday tho not my room key
obviously get my carkeys go back downstairs remind them i
won't be up for breakfast so don't go ringing that bell of yours
& banging on my door for me to wake cos i ain't interested go
out to the hardcourt open the door to my car scoop out several
cassette boxes of water from the footwell (even tho we ain't
got a tape machine we got the water) get in start her up first
time reverse onto deganwy avenue drive down lloyd street
watching for shoppers smasht glass side streets tourists for
chrissake women across st. george's down to the parade the
promenade & they'd surely still be tripping over their wellysuits
pushing the fucking boat down the street. jeezus. what a place
to put it. who owns the front anyway? *'for those in peril on the
sea'*. the ambulances are kept in a pool apparently.

...

high street; mostyn street

the carlton with its beautiful bevelled windows
& BIG screen telly

the carlton opposite the *'weigh & pay'* bookstore
&
'travelworld' 'chinacave' 'b'wise' 'mothercare'
the *victorian* shopping arcade

clifton
rosebery avenue
st. mary's next to caroline
makes me think of me own streets

jezus i travel shit.

north shore
happy valley
the pier

all worship the great orme

church walks
abbey road

west shore

lloyd street west
the oval

back to me bed & breakfast home

...

speech:

"lunchtime pint?"

"you can mate but i'm not."

"come on why not?"

*"cos if i go into a pub i'll get pisst. when i get pisst i get
full of myself when i'm full of meself & me potential i get off
with people if i get off with people beautiful drunken women i*

risk most of the good things in my life if i risk the good things in life the things i worked so hard to get the woman so hard to get i get depressed & dispirited within myself disgusted disappointed with myself i get vicious

"vicious i get vindictive vindictive i get dangerous dangerous i damage myself sometimes internally sometimes sometimes those who just happen to get caught in the blast sometimes on the end of another man's fist when i get hit i bleed & i'm not so keen on it

"if i don't i mourn cos i can't have it all when i mourn i get miserable when miserable i'm vicious vindictive malicious & shit company. you go for a lunchtime drink if you want but not with me you go with me i'll fuck ya missus bigtime sorry i'm just telling you how it is cos you're my mate

a coupla beers i'll be tryna get in her knickers busy tryna get her out. gota control my desires & concentrate in one straight line i am living a temporary life of false guides. do not trust in them. you know what's right.

"lunchtime drink? yeh come on en/nah what you tryna do to me? i'm already in a fuckin state..."

...

the code of coeds

i am rotten to the core

i have attempted to reflect the shit which surrounds but instead i absorbed

& now search for the return of the the the
for which i was known

ah fuckit

SUCK MY COCH

as i should've said before.

...

you can only hit your head so many times against the brickwall
before you have to wipe the blood from your eyes

the garden gate of veins on my hand

jettison & getsome

shambollock
dis-crete

victoria sponge
scoop of pink

jargon comparison
transmit:

due to a typing error i will from now on be known as
'hmpossible'

bleep.

ansamachine.
answermachine.
andswearmachine
you fuckin shit.

...

but i love all women

i stand in my doorway alldaylong & ogle their eyes cheeks lips
neck hair breasts arms wrists waist ankles calves thighs back up
& down the otherside as they walk passt alldaylong, but i no
longer ogle, today i *consider* each one

i love women & i consider them all.

i love in you the girl i have known but now so we may further
develop our bond you must play your next song the woman in
you

it has not died but risks it risks the next move
forwards or backwards no standing still
i still love you
we gotta choose to
move on
up or out.

you are my love & i've known this since you first chatted me up
affirmed with that translucent dress you wore that first morning
i walked with you after that first nite with you we parted at
charles cross the wind picking up & the sun well above us just
as i went underground down the steps to the underpass you
smiled at me then carried on to the campus & so many times
since we've confirmed our love for each other which started so
simply: i attempted to seduce you. you seduced me. i
succumbed. resulto. perfect.

but now i find i *consider* & i'm not happy about it. it means
something's crunched. but we talk about & we do still love.
both wanna iron it out so we can get back to ogling enough.

...

there is terror in permanency
in no turning back

like looking into the eye of (pause)
the beholder

bubbled water thru recycled glass
or cubicle plastic

running from the devil
from the tap

how older i am.

when my brother mentioned age i told him *"all in the mind"* like
i knew what i was talking about. but then i'm younger, not so
bothered - that's a difference in our lives.

but there's definitely something happens, comes outa nowhere
& it's obviously an age thing but my age it means nothing it's
stages i'm interested in. stages of existence. trip stops.

i'm entering a new one. i recognise now that's what all this
twitching's about. well fine, shake it off or roll with it, see what
comes out.

...

shower on. blast off.

hoping to take her with me
if she wants

(but if not? but if not?)

full hot.

life's like that!

from our reporter in the field:

the young & handsome married man was seen to leap down
onto the pad delighted to see her
waiting for him.

she ran!
from mother to father across tarmac.
he:
crouched in advance
slid hands between her torso & arms
lofted the toddler!
launched solo up to the stars
tossed high to the sky!
as deserving of such a wonderful wholesome
cornflake sundrenched day
her hair to tint sunrays
whada life!

she *giggled!*
at seeing her papa smile, position & prepare his hands to *catch!*
at the *experience!*

while she absorbed the moment to playback
the feel of her father's breath
& the cool fast *whip* loosening her hair
caught frame by frame
a microsplit fract time spent without care
a rotorblade **THUNK!**graind her head & continued to
whapwhap
the air.

& her father...
father felt current between daughter & head yet still
anticipated to catch her descent
only this time
(hands primed for armpits, the same as she left)
her torso slippt hands
as he caught her
bodiless
head.

& amongst the *whirl* & **THUNK!**echo
of the toddler
hitting rotorblade
a cleancut rainbow rush contact was made.

a splash on his cheek

& his daughter's name was
irrelevant
but
helly
would be a
dead
sick
suggestion
to make.

...

a splash of red
from your faithless correspondent
human interest ed.

(fao. the reader's digest...)

i hoped i'd never
(hafta write this fucking shite)

so this is the danger time
right now
right now
this is the moment
post mortem
post discussion
post little red car
post hose thru the window
post photos of us kids on the dash
post two hour phone call to your sister in australia in the middle
of the nite
post phoning another sunday lunchtime from the clifton
& going round
telling them all
i dunno i dunno
just that.

post notice in the echo
post my buying decent clothes & shaving & singing
'abide with me'
at the top of my
post choirboy voice
from the front row of thornhill chapel of mercy
post sunshine
post funeral
post fags in the carpark with my brother, sister, cousins
post wake at my house in ruby street
post poking for info about you growing up in emerald
post getting out the photos of you marrying my mother
post tales of your roguery

post trying to explain to people who thought they knew you
so well
your bi-polar depression
post trying to say the right thing to longterm
friends of the family
who tried talking you out of it
post dialectics on the rights of self-harm
post acceptance
post good wishes
post perspective on your living
this
is the time
when it all
comes together
comes down
sinks
in
when the stomach of events lies me heavy
when i've stopped
momentarily
getting pisst hugging niteclubs
full of sobbing
looking for fights going home along queen street
getting dragged away by sally
telling some poor bloke he's
"so fucking lucky!"
to avoid a smacking

when
everyone's stopped asking
"you ok?"
"how ya dealing?"
post good friends out the woodwork
post poor friends to oblivion
post people showing their mettle
me also

"yeh i'm fine"
"thanks for asking"
lying

but
this now
is the time
four o'clock in the morning
pisst stoned & writing
furious & writhing
no choice & no option but
feeling
less stressful than sleeping
dreaming
no avoiding

this
now
is the time
when it all
kicks in
when i face the inexplicable rattle
the implosive desire to kick some fucking cunt's head in
not kick it in but
stamp on it
viciously
heavily
& make it bleed for every inch of my being
for every inch of the rubber from exhaust to your breathing.

~

i read your letter for the final final time.
it begins:

"My lovely boy,
Lloyd, this is the easiest and yet the hardest
of all the letters that i will write today"

& it tells me of your life
& of your death
& i wept
& i will weep again
& each time i promise
sweet jesu!
i will not become you
although echoes in my head:
"you & me Lloyd, we are both the same"

- as tempting as it seems in ways
as truthful as it is in ways
i will get my head most righteously smasht in
before i give way

whether this by someone else
or lloyd charles ellis robson
i cannot say -

& this is why
such a dangerous dangerous
this is why i stay awake all nite
& through default
sleep part day

- but maybe you did (get your head smasht in)
& only then
gave way?

i should be careful with my claims.

~

i cannot be sure i will sleep
nor wake
again

i cannot write of you further
(but i will, one day)

if nothing else:

if ever i needed a father
this is the time for you to say
anything
but:

> *"By the time you read this the old man will be no more.*
> *I have so much that I want to say..."*

this is just to attach exhaust to hose

i have **taken**

THE KEYS

that were in
the icebox

and which
you were probably **HiDiNg**

til breakfast

forgive me

their expedience

so sweet
and so cold

surround myself with busyness

you say i should cease sport & my attendance it brings my aggression to sore throat & dagger-eyed self-defeating extremities i will give myself a heart attack or cause some fuck to shit their pants which really is unnecessary considering the circumstances.

you say i should slow down with the booze it makes me think i'm seventeen years old not seventeen first time but seventeen & more so. cock of the walk up for a fight up for the eyeball psych out duel or a scrap i will lose while gaining the joyous experience of getting a bloody good battering & a black eye for the girls the women i could have if only i was single. the bottle over the back of the head from her husband when i'm not looking the prize of a cuckold the reward the excitement.

you say i should stop using drugs it confuses my attention intention & abilities to differentiate between real & imagined worlds they magnify & render invisible they split my already multi-divisible person fill life with irrelevant layers of reverberance & disturbance they shuffle my refusals.

you say i should exile extricate eradicate extradite disband debar & red card certain individuals from my mind even more than from my presence remove their cookie their worm their virus from my system but protectors have no update i battle with infection.

you say i should find peace with myself for myself & by myself & call a truce with the world & its people but trust & faith were tried & found treasonous in their claims deliberance deliverance & deliverers were conniving & brutal.

you say i should listen to myself & to what i once imagined. *pah!* i visualised goodness & wisdom, not shit shovels without heads nor handles & steaming piles of never vanishing issues. calm & simple pleasure not brainstorm & lightning bolt fusing the perceptions. midnight attacks, imaginings & interpersonal suicide bombers killers fiddlers queuing next to my bedside table.

you say i should compare what i want to what i have. i remind you i want to get through this better this & achieve such things if only i could have two minutes without questions. numb dumb & insensitive if only for an instant. who i wanted to be with who i didn't. i tell you i would like this but cannot remember past the concentrated insistence of the shadow i have become of him.

i remind you i live in a circle. you say i should square it. so i do all this.

i take you at your word & strip bare remove defining factors to see what remains of this shaft of flesh & the beacon & whistle that live in it. look deep down dark & light & honest into the prism the mirror the spotlite & i see the love the bitterness the brave dilemma the fear & still it leaves me

debilitated, not so vicious maybe, eaten by my history & its unhappiness reverberates even louder surer shaking my bones bruising the extremes of me loosening the appendages the eyes from their sockets the wax from my ears the juice from my sack the grease from my elbow the knock from my knees the nails from my toes & my fingers crease arthritically

& i can only decide not to listen to myself again for what i find is nothing without his influence. & what i want is me & me but what i find is me & him & i don't like my life like this.

i didn't see the betrayal coming from inside the wisdom. i didn't fathom the knife in the back would be knock on the door parcel in hand delivered by uniformed courier with a fucking great neon sign on his cap. i didn't realise i was knowingly signing cash on the dot for my own denial hoped i'd have the knowledge the suss the nous the reaction the wherewithal the half a fucking brain necessary to at least defend myself from my own experience dream & imagination.

& now that you have talked me into this now we chat friendly perched on the edge of things there is nowhere new for me to go but for plodding & plod i do not do so well. so *bbboing!* onwards i go bouncing rebounding ricocheting occasionally resting swirling swerving redirecting playing chicken blindfold kamikaze out of the sun veering exploding convincing myself that maybe through busyness comes solution directionless at warp speed maximum into space time & this limited down ticking existence & eventually one of these bumps will do for me unless i find the brake & pull in but then *aha!* the brake could well be the untimely shock to the system.

is it death? fuck death that's the least of my worries. death is a piece of piss take my word for it clips you or you choose to cease it's living or rather choosing how to with the greatest ease & success.

define success.

so i've seen my future. i know what awaits. but all you see is me sat here staring at myself & the blank page, going around in circles with the fleck in my eye my diaphragm stressed a head full of heritage & a deep breath braced desperately trying but not wanting to exhale nor face the next test

test what test? fuck that, it's experience.

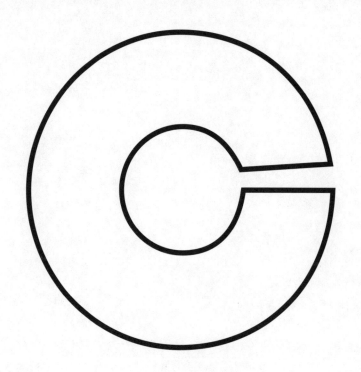

sense
of
city road

'sense of city road' is an ongoing project based on city road in my home city of cardiff, wales, UK. the first phase was the writing of a poem entitled 'sense of city road', the second phase was the completion & display of an image & text (photo poetry) montage which would serve as defence, record or glorification of a sometimes unfairly maligned thoroughfare on the unfashionable side of the city.

this montage is a mix of text & image; poetry, photo-documentary & abstract imagery. it represents a walk up city road & contains as a continuous narrative the poem 'sense of city road'. unexpected glimpses of city road's present & previous lives have been framed, documentary images have been overlaid with text, sections of microfiche containing random company records reflect the rapid rate with which many businesses open, close or fold on city road. it is a recording of layers of temporality which instantly become out of date. 'montage' refers not only to the mix of text & image, the nature & content of some of the individual shots, but also to the overall effect of the individual frames on each other.

it often seems no one considers city road to have a value (& as such city road represents the wider roath-adamsdown-splott axis of east-central cardiff), so i decided to counteract that. i wanted to show the potential for art (on a day to day level) present in the seemingly mundane, while also asserting the right of the area to be considered interesting, or beautiful, or detailed, or any of the other descriptive responses it never seems to receive but to my mind deserves as much as anywhere else.

i started the montage in 1993-94 (i forget exact dates) while living off city road on the corner of glenroy & plasnewydd, in the east-central roath district of cardiff. i felt the area was taking a lot of flak for its appearance, cultural mix & opening hours, & deserved to be defended. city road was far from

being the best maintained street in the world but it had a lot going for it. & still does. for all it's ugliness it has a visual beauty found in its partly hidden architectural detail, its surfaces & textures, in the images & visions they offer if you want to look for them.

my intention was, as far as i can tell, to attempt to capture, record, praise & bring attention to a neglected yet culturally & historically vibrant stretch of cardiff. to show the low-income working-class area i'm from (if i'm from anywhere) in a positive light & represent it as i see it, in detail, text & reflection. i wanted to produce something attractive out of maligned raw material (city road has long been an ideal target for urban redevelopment). i also wanted to combine my two main creative activities: poetry & photography. sounds simple enough so far.

the intention behind the montage was not to produce a historical record of the area but an alternative record of the area; an alternative which displayed the substance under the surface rather than reflecting the common perception of what city road is, as held by many who know it (so they stop looking) or know of it. but to claim i knew what i was doing from day one would be a big lie; that i had one central idea, a clear focus. bollocks, i've never had a single clear focus in my life. in some ways i didn't have a clue, i juggled, went on instinct. i knew i was up to something & i'd get a finished work out of it, but what shape that work would take & the full range of intent & meaning wouldn't be clear to me until much later in the process. that's how i write. i'm told by other people that's how *their* work is produced. *"what are you working on?"* i have no idea, something, it doesn't matter.

looking back i was well fortunate to get support from the arts council of wales & for that i am extremely grateful to tony bianchi & richard cox (& later to angharad jones) for the faith

they put in my ability to finish what i started. consider this: some stoned guy on the dole comes asking for money so he can complete a photographic project. is he a professional? no. trained? no. did he go to art college? no. does he have a track record? no. does he have a body of work behind him? no. under normal circumstances i'd be kicked out so fast my arse wouldn't touch the floor. but then the project was going to happen whether they were on board or not. they may have sensed that, i don't know. maybe i should ask.

during the time it took to complete, the montage mutated significantly. by the autumn of 2000 i had spent six years walking up & down city road photographing everything & anything i deemed worthy, getting stared at like i was a loon, hassled by chopsy schoolkids who wanted to be in every shot, chased up the street by shop staff who thought i must be collating evidence for the police, the press or environmental health, trading standards, or immigration departments. shit like that can wane your enthusiasm. i tried exchanging pleasantries with a traffic warden in an attempt to rebalance my humanity & gain support from another more experienced with shun & suspicion. only to be told to fuck off. estate agents treated me like a friend, thought i was one of them, asked when the building being photographed was going on the market & for how much. for many, cameras are the enemy of the people & who can blame them, these days you can't take a shit without some nosy cctv bastard zooming in to count the number of sheets you use to wipe your arse.

on city road i took shots of road signs, shop signs, flyposters, vehicle livery & graffiti, so using spraymount & scalpel i could recreate the words of the poem from the actual text of the environment, much like a poison-pen letter created from newspaper headlines. i combined these words with documentary photographs of city road to make up the complete poem & surrounded these with alternative views &

alternative narratives: abstracts, reflections, textures, architectural detail & found texts. every image, every piece of text, was photographed in the city road area. in more ways than one i spent those six years going around in circles. we live & learn. hopefully.

so what is city road?

city road's this stretch of dodgy tarmac from death junction to the (now closed) infirmary. it's generally maligned, slagged off, deemed common or rough, a disgrace to the name 'roath' & the genteel aspirations of roath park, a loud obnoxious sick-splashed tuft of nuisance to residents, a fousty artery leading out of the city, for some not fast enough.

while our city centre makes desperate attempts to be perceived as european, city road is, not only in its multicultural nature but also in its opening hours. city road is capable of operating day & night, much like the european cities held up as examples of healthy street life. while the cardiff featured in glossy brochures attempts to give the impression of the civilised 24hr city culture of mainland europe, city road achieves actuality over appearance yet gets a bollocking for it. there's a moral question here: some people think if we stay up late & wake up later we're lazy or up to something & 24hr opening will only encourage this, but what about the night workers, the night socializers, the unemployed? after all, unless you absolutely have to, why bother to wake at 7 in the morning? society is changing. we are redefining our timetables to suit ourselves & our activities so available services should mirror this. quality of life is not about impressing others with the appearance of our city, it's about providing residents with somewhere to buy milk, fresh bread, bogroll, petrol, a game of pool; amusement, a social life, employment, a stroll to the shops or anything else we fancy whether day or nite. city road may not be the prettiest street in the world but it has its history,

culture & dynamics. city road is organically cosmopolitan & should be given every opportunity to thrive.

to many people city road is either a street full of secondhand car dealers or a street full of fast food joints. in reality city road is far more diverse. it serves a whole myriad of business, service, culture & people, yet it rarely gets money spent on it & people seem happy to run it down. it's a shame so much money gets thrown at areas where no one lives rather than on areas like city road where people reside, work, shop, socialise & mix. it's important cardiff raises its public profile but we seem to be caught in a pattern of public spending & urban regeneration more concerned with what the outside world may think of our city rather than improving the city for those of us who are already here. (to be fair, since this segment of text was written for the exhibition, cardiff council has implemented a programme of redesign & regeneration for city road & has spent money on it, with mixed results.)

as a geographic strip of the capital, city road acts as litmus & chain, testing tolerance as it links the wealth of roath park, lakeside, cyncoed & penylan hill with the poor of adamsdown & splott. it is historic & modern, runs from the site of the gallows (death junction) to a major six-lane city artery & the central hive of industry & commerce. it contains movement; reflects the city's status as a long-term multicultural home & its history as the world's busiest coal port, bringing in sailors & refugees from all over the world. it also reflects cardiff's other cultural wrestle between the cymraeg-speaking & (so-called) english-speaking people of wales. city road represents the working present of the city, its past & its invigorated future as europe's youngest & supposedly fastest growing capital. city road is a road for all cardiff & all wales. just as it reflects this, so this montage reflects city road.

the poem - sense of city road

closed open open close
foodshops here have senses others don't
people trounce up city road milling spewing myriad colours
absorb absorb
glutamate agglutinate cultures
absorb

> (your diaphanous seeds
> life & risky exuberance
> *absorb!*)

spit sperm & sulphurous dioxides spring from sewer
& roadside food spills

environpollution tastes lap rat pigeon bare cupboard
residencies
side street
past side street
past side street

battle *munchmunch!* absorb
munchmunch munchmunch
battle - with relish - *absorb*

(first published in 'city & poems', blackhat, 1994).

hmm. this poem isn't the greatest thing i've ever written, it isn't
even the greatest thing i've written about city road (check out
the novel/prose-poem 'cardiff cut' for city road in greater
detail), but it was the spark, the catalyst, which led to the
creation of the montage as well as much of the work in 'edge
territory' & also 'cardiff cut', so to have abandoned it for a

preconceived text would've been wrong somehow, artificial, unorganic. besides, it contains the line which cuts to the core of my thoughts about city road: *glutamate agglutinate cultures*.

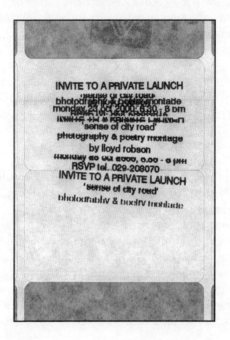

the exhibition

the sense of city road project reached the completion of phase two during 23 october - 4 november 2000, when the photo poetry montage had its debut exhibition in a temporary art space on city road. i organised the exhibition myself because i felt it important the montage receive its first showing on city road, so it would have the opportunity to take part in its subject matter & not just reflect it. (besides, why piss about in discussion with galleries when you can get off your arse & have the show done & dusted in a month?) i also wanted the people

who lived, worked, shopped or socialised in the city road area to be the first to view & judge it. as you may have gathered, city road doesn't have any permanent galleries, it's not that kind of street. not yet. coincidentally, the exhibition offered an alternative or a supplement to the touring 'british art show' which had cruised its limo into a number of cardiff's permanent art venues at the time.

the exhibition was open six days a week from 12noon-7pm or later. most days i was there, otherwise the exhibition was staffed by my then partner sal or my cousin vicky who spent the time checking who went in & out of the income support office opposite. snooping on the snoops. i like it.

all kinds of people visited the exhibition, most of whom were delighted to see a reflection of one of 'their' streets & to have the opportunity to talk about city road & its changes throughout their lifetimes. in this sense it was a great communication tool. we had some pretty interesting discussions about the future & history of city road, what it will be & what it should be, & its role in this part of cardiff. of course a lot of what i photographed was out of date by the time of the launch exhibition, but that's city road for you: turn your back for two seconds & it's different. at least we can rely on that.

several hundred people viewed the exhibition, from cardiff, the rest of wales, england, italy & greece; local residents, workers, shoppers, members of the city's art communities, also students from howard gardens art college & newport school of art, media & design who took the opportunity to question me on my intention, motivation & method. some locals showed up feeling defensive, presuming i was taking the piss (*what possible artistic merit could city road possess?*), but seeing the work, being able to judge for themselves the montage's content & comment, being able to speak to its creator (me),

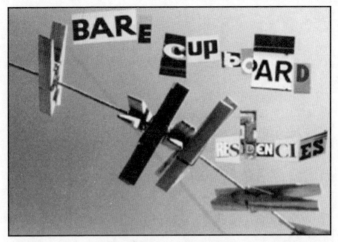

a washing line in glenroy street, off city road.

the welsh dragon on the parcel shelf,
city road reflected in the glass.

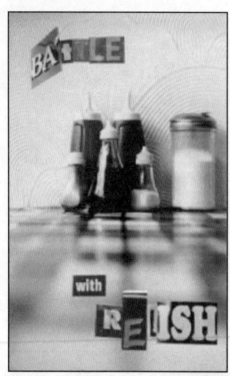

happiness is... the window table of a city road caff.

the upstairs window of the empty barclay's bank building on death junction. the old glass adds a paint-like texture to the reflection.

being able to see & hear for themselves the positive intentions for the project, seemed to reassure them, enthuse them & encourage them to see familiar surroundings with new eyes & in a more positive light. also, they got to see some art for free - not a regular occurrence on city road. others showed up curious, bored, trying to get out of the rain, genuinely interested, or by accident: the property had been home to the 'welsh water' shop, where people could pay their water rates & report leaks. the shop had closed three years earlier & had sat empty ever since. still, during the exhibition a number of people called in, confused as to why i wouldn't allow them to pay their water bill & threatening to take their complaint further. bizarre. ghosts of urbanity. temporal spasms.

one of the comments made in response to the montage was *"there's not many people in it"* but of course there are. there are over 70 people in 53 frames, they're just not centre frame. there are no portraits, no easy collections of wizened local faces, no mugshots (people like mugshots, they know where they are with mugshots). the people are edge-of-shot, in the distance, in corners, reflections, shadows, pushing passed with shopping bags & baby buggies, drinking from cans, getting on with it. the aim was to represent a stoned stroll down the street. you don't stroll down city road getting face to face with people, you don't eyeball or make them the centre of attention unless you're eyeing them up or looking to kick something off. to reduce the montage down to portraiture would've been condescending, artificial & tragic. it would've been a surface representation rather than of its environment. it would've been a benetton ad at best & not very imaginative. am i getting defensive? too fucking right matey, you've missed the bus with this one.

the 'sense of city road' montage was part-funded by the blackhat smallpress & was sponsored by jessops, the high street photographic retail chain, who supplied free film &

whose staff put up with a lot of tantrums & favour-hunting from me. a big 'ta' goes out to them, also to cardiff's innovative artist-led gallery 39 & chris brown in particular, who was on hand to provide enthusiasm, advice & support when i needed it.

the debut exhibition at longcross court was sponsored by hyder property services who provided the empty property, the city road branch of bottoms up who gave me a good deal on the booze for the launch event, & the frame factory at 202 city road who did a great job of preparing the montage for exhibition. others who helped with the exhibition include chris brooke who established the project's first web presence & was on hand - together with sally wallace & meins slaymaker - to assist with hanging, the nite before we opened. so, with all this help & support did the project stick to budget? did it bugger.

other costs were almost too ironic to bear. my father gave me my first real camera when i was 14 years old & taught me how to use it. just a cheap & tatty 35mm chinon CE4 manual SLR. i used the same equipment some 11-17 years later to take shots of the area he grew up in & which played a formative role in my own childhood, for the montage. while working on it i also used two other camera bodies: a secondhand chinon CE5 (the same as my father bought himself after giving me his CE4) & a new centon K100, with a small range of PK-fit lenses including the normal & wide angle lenses my father had given me to complete my first camera kit. by the time the exhibition was ready to open the relationship between me & my father had long gone cold. the montage launch event was organised & i didn't invite him. at the launch some little shit sneaked out to the back room & stole a camera & lens. fortunately it wasn't my much loved battered-to-fuck CE4 but the lens *was* the wide angle my father had given me. not worth anything financially, but a hell of a lot emotionally. i felt the crime was probably justified: it was city road reminding me its reputation ain't for

nothing, it was THE COST (everything has a cost) & it was a slap to repay me for not inviting my father. a few weeks later someone told me they had seen me dad on city road so presumed he was on his way to see the montage. he didn't show up. maybe he stood at the door but i didn't see him, although at one stage i did feel he was close by but brushed it off. within weeks he was dead. the hex on the thieving little turd who stole my father's lens from me is mighty. thieving too has a cost, it'll catch up with him even tho i won't.

my most lasting memory of the exhibition? apart from having my soon-to-be-dead father's camera equipment nicked from under me nose? on the last sunday nite of the exhibition i locks up & goes to me car in the covered car park behind the shop where i finds three teenage twats setting fire to a tramp's shopping trolley & possessions, dangerously close to the fire exit at the back of the shop. no sign of the tramp. now i knows i'm on dodgy territory so i doan get too close to em but i had to give em a bollocking for burning the poor guy's stuff. i gess a right load of gob back. only to be expected. so i suggests they're in danger of setting fire to the shop. *"iss alright"* one of them sez *"iss a fire door"*. *"you dozy cunt"* i reply *"that's a fire exit not a fucking fire door, don't you know the difference?"* i drives off with the three of em righteously slagging me & hand signals a-go-go from both sides. i gess home, phones the security guard in longcross court who's been looking after the shop. no answer, so i thinks he must be down there sorting em out, thass why he doan answer. i leaves it at that. didn know he had finished early did i. but someone from the flats calls the fire brigade & the shop doan get burned down. thank fuck for that. buh they doan catch the little bastards neither & there's me thinking well i could fuckin spot em & why didn i phone the fire brigade meself. thinks they must have security cameras in there somewhere & they'll be caught on tape. maybe they do maybe they don't. it annoys me for a few days then i leaves it alone. a year or so later two 16-year-old lads sets fire to a tramp

who had been sleeping in a lane off city road. the guy's had it; spends two weeks on a life support machine then two months receiving skin grafts & dies like weeks later. at least these little shits get caught & sent down for it, but i still doan know if it was them same boys i saw around the back of the shop. if it was them it means i coulda done sumit & maybe that bloke could be living now; that i had an opportunity to change the future & didn't take it. if it wasn't them it means there's more of these sick fuckers out there & there's a social trend growing. what a hobby. whass going on?

the future

the montage consists of 53 framed images displayed in seven sections. individual images measure from 197x180mm to 509x407mm & the complete montage requires approximately 10 metres of wall space. two frames have been exhibited by the royal cambrian academy as part of their 'young wales V' show, february-march 2001, but getting the montage to have a life of its own is a full-time job in itself, especially as it's perceived to be so site-specific, so for now it's in storage, available for exhibition if anyone's interested. will it mutate further? possibly. probably. i'm thinking of printing the whole thing frame by frame on one long thin strip of photographic paper. but for now i'm sick of the sight of it. that's my prerogative. i'll get back to loving it later.

the larger 'sense of city road' project may also expand into any & many available media. will it? i don't know, but i expect so. city road continues to appear regularly in my writing & i get the feeling it concerns itself with me (like a dog worrying a bone) rather than i concern myself with it.

these days i can see that photographing text is just a reflection of my belief that text has an important visual role which is often underplayed, denied or ignored by writers. also, in my own

mind it's further proof that i'm no longer sure where my writing ends & my photography starts, if ever i knew in the first place. in this sense i'm not a photographer but a writer with a camera. judge that as you will. we can capture images with a typewriter, so why not write with a camera?

as for city road itself, it's neater than it was when i began the project & quieter - which was probably the council's main intent - but there's still plenty more needs doing to the area.

as for the tramp, his death remains scorched into the paving stones & history of city road & into the memories of those two boys.

life lite

notes from new york state

my first nite back in the states & i'm watching charleston versus some fatarse baseball team on the box behind the bar. the barmaid is gorgeous in her blonde hair black eyebrows kinda way & the guy sat next to me has just had his steak placed in front of him - not steak & fries nor steak & gravy pepper sauce mustard onion rings peas beans assorted vegetables root or otherwise, just an almost cooked lump of cow; a big fat fuckoff steak on a plate sat next to his piss beer. he tucks in, understandably. i'm starving. i've got money in me pocket but i can't be arsed to eat, i'm drinking & writing here. sinatra's taking us to the stars from the booths while the tv commentator gives us batting stat platitudes. i'm new here, still to rediscover my stateside feet & in this bar, wherever we are, there are too many people speaking i-talian for me to possess a feeling of total security. i'm still in this state of *'america i have seen on tv'* rather than *'america i have experienced'* or *'am experiencing'* besides i was pissing it up on gratis merlot for eight hours straight flying here so who knows what i'm really feeling. internally i am still moving i left home what twenty two hours ago did the coach to heathrow longhaul boeing to washington little elastic-powered chugchug flight from washington to here most of which i spent looking up the stewardess's skirt sat as she was outside the cockpit facing us & surely aware of just how far her knees were from each other - excuse me while a pause & contemplate for a moment - it was hard to avoid getting sucked in. arrived at my accommodation dropped my bag washed the shit & sweat off my face shot off looking for a bar got gobbed at walking down the street - the first local resident i meet - some guy blasting after me with: *"hey man, don't you walk round here! don't you walk like that! come here! come here!"* like i was gonna stop & chat, stomped

147

down the main outa town drag found this cosy looking i-talian steakhouse pushed open the door & sat my skinny ass as close to the blonde black-eyebrowed barmaid as i could get away with & ordered myself a beer *"sure, what would you like?"* jezus, gimme a sam, i can rely on that. cheers. so i'm sat still but my system is still moving with the tug & the shuffle & engine vibes of diesel & high octane aviation spirit. i'm all aquiver & it ain't just the barmaid that's doing it. it's all pretty trippy & i ain't yet sure of this place so i'm rehearsing the bridgend italian prisoner of war camp story just in case. you ain't heard it? buy me a drink in an italian accent & i'll tell ya, but then ask anyone in south wales they can tell you the same.

now that i'm sat down i can refocus a while & i can see they've got bold cartoon caricatures on the wall, of lucky luciano threatening to show me the bullets as well as the gun & behind the bar the biggest bottle of chianti i ain't ever drunk. like fucking huge. having drunk the red to green in double figures all those little aeroplane bottles & a fair few still waiting to be cracked rattling around in my carry-on case the wine seems more of a threat than the evil eye i'm getting from the mobster & the sly *'hey who's our out-of-towner?'* looks i'm getting from the drinkers. if you ever wanna be treated suspiciously by both staff & customer just start looking around & writing it down in their presence, it fucks with people's paranoia & americans do paranoid good. *yeh i'm writing a report on ya & boy are you ever in shit when this gets filed! i've been following you for days buddy, keep an eye out...*

but fundamentally this place is no more threatening than t.g.i friday's on cardiff's newport road, even less so - here you don't get terrorised by badge-covered brace-wearing bottle-lobbing arseholes all tryna be cheerful. here they just are. or not. no acting. thank the lord for that huge mercy.

so i hang around & drink. steakman has his fill & fucks off home

or to find some skirt who'll do him in the carpark quick. i go take a piss & get a touch para meself: i got something like a hundred quid, four hundred dollars, eight hundred euros, a passport & an internationally accepted piece of plastic & it's all in my fat fucking wallet stuck out me arse pocket like a stolen child screaming out the back of a truck. *SAVE ME MAMMA! SAVE ME!* so i slash & shake, stash the plastic & a wack of cash underfoot in me stripy daps, leaving just enough greenbacks to cover me tab should i stay a few hours & some of the euros - no one here's gonna nick them, any yank heavy who fancies relieving me of my cash on my walk back is just gonna think if it ain't american it ain't real money & leave me to it. well you heard it here first brother: watch ya back federal reserve washington hamilton jackson grant, annuit cœptis the great seal in god we trust the euro's gonna bite your fat ass we are coming to get ya. once we get rid of sterling first. people go on about the great threat of the euro to the british pound. well frankly, as a welshman maybe but also as a citizen who considers his right to claim britishness active, the idea of fighting for a currency bearing the face of a fat german monarch with a greek husband ain't exactly my idea of upholding national stability. no disrespect to the germans & the greeks intended. besides, you take the monarch's mush off of coins notes stamps offa legal tender & she ceases to exist in the lives of the average british person. the presence & relevance of regina or rex dissipates & evaporates. so sooner we get the euro the better: no kowtowing to self-righteous inbred monarchy here, it's all architectural detail & bridges. nothing wrong with that, good positive symbols, but the notes don't tell us the european locations which is a pretty poor design oversight. any road, i got an idea: bearing in mind to stick a british postage stamp upside down is officially treason, i think we should all do this, post to ourselves envelopes bearing the offence & then take said articles to the police & hand ourselves in, insist upon our arrest. if everyone did this they'd be swamped & soon remove the monarch from the stamps just

for an easy life & no longer would we have to lick lizzie's head. heesh.

i've drifted for a moment. fold & pop & put me wallet away, relace me daps, wash my face & hands, towel, check the mirror to make sure i don't look too mad (turbulence crazy, airmile zapped), deep breath, open the door & return to the bar, order myself another beer although i haven't finished this one yet & scribble something down on a soggy napkin, something i won't be able to read tomorrow morning; something in the bend sinister, the devil child's teeline, my cack hand. i need to discover how to decode my own cypher.

the game's changed. on tv. clemson versus south carolina. it has the feel of a reserve game or a testimonial challenge. i think of the roath park rec but from experience i know how attempting to explain to americans how we in wales play baseball with a three-sided bat is a nitemare non-starter. they can't wrap their heads around the idea; think i'm having them on. *no honest man, we've been playing baseball longer than you have & the real game's played with a three-sided bat.* they react. they are... mortally offended. it's like i said the statue of liberty was modelled on a french tramp who liked to give out to all & sundry, the liberty being those every jack with a dick took with her - in return she gave them all the clap. so america the brave, you're the sons & daughters of a clap-riddled whore who's been fucked by half of europe. something like that. only worse. much worse. *baseball is american son & it's played with a round bat, that's our heritage.* what? so three sides too complicated for ya?

jezus. by rights it should be three o'clock at nite in the morning & my head's starting to act like it so put it away boy put it away & carry on drinking you are feeling just a little no sleep neurotic & new town insecure. chill out. get with it... i calm myself, remind i'm just beginning the latest leg of my american

experience. a big smile hits me & holy fuck you know what? i get with it pretty quick, gimme a beer.

i get talking to a big guy at the bar. ron. he's a regular; slow, friendly & calm. i explain who i am in as brief a way as possible like i'm a foreigner who's just this minute arrived & more importantly where i'm from. he's heard of wales, knows where it is; i don't have to tell him. he's a self-educated working man. i don't overplay my delight at having my first non-purchase-related non-time-killing conversation in days & i warm to him. he could be an uncle, he's a reassuring kinda guy. i buy him drinks although he insists there's no need he don't want anything other than to talk & this makes me all the more determined to put my hand in my pocket & pay for his. buying other people drinks'll be the end of me. but i gotta go. i'm getting pisst quick. it's like warm & civilised conversation has let the cat out the bag. suddenly the long day of transatlantic drinking is beginning to catch up with me & whereas so far i've been balanced & considerate & civilised i'm kinda warming to that out of control gob-a-roon-a-soon scenario which would turn ron's evening from interesting or different into at best annoying but more realistically *"i couldn't shake the damn white drunk so had to leave MY bar goddamit!"* & i don't wanna do this to the guy, it's a wednesday for chrissake. so i begin my goodbyes. i ask the barmaid about getting downtown: easy, only fifteen minutes if i'm driving. i ain't driving but i'll walk. she looks at me, sez *"you don't wanna be walking around here. but if you do, go now, before it gets dark"*. goddamn werewolf country. ron asks where i'm staying & how did i get here. i tell him in the nearby heights & i walked. he & the barmaid look at each other. she ain't sure, but anywhere outside of the safety of a motor vehicle ain't at all recommended. drink driving is perfectly acceptable under the circumstances. she adds: *"you should call a cab. this ain't the nicest of neighbourhoods, especially if you don't know it"*. i say it seemed ok walking down here - apart from the guy who

chased me out of his immediate territory shouting & bursting bloodvessels like a drugged up racehorse for no apparent reason - but i take their advice & the card from the barmaid with a number on it. not hers but a cab firm's. i question myself for a second whether this is good advice or cahoots with the driver but fuckit, taxi's cool by me but i gotta remember to ask drive for a receipt, who cares if someone else gets a commission? not me. besides i can't be arsed to take the risk, i need me ride down easy street to the city of deep sleep. hit the booth pull a quarter & call my car. get back to the bar & order one last short each for me & my bar buddy ron who i figure hasn't got as much out of this meeting as i have but i dunno i've been just about lucid & sensible so far, straighten the tab tip the barmaid & the cab's here in no time. which is just as well cos i'm about to launch into a new conversation without my brain in gear & that's what i'm purposely avoiding. goddamit i'm a cultural fucking ambassador representing my country *behave yourself!* on the first nite at least.

i shift my weight, straighten my jacket, check my passport is where i left it, reposition the visa in my trainer so it don't snap when i'm walking, shake ron's hand & look him in the eye, get outside & into that big old lincoln full of trust & bemusement. *"yes sir, where can i take you?"* alright mate, i'm staying at a place called furry hall, ju know it? *"furry hall did you say?"* that's right mate. splendid.

as a kiddie i was drawn to the row of 'spanish gold' sweet tobacco sold in cwmbran woolco's. man i loved that stuff. it was 'real' (not real) chewing tobacca in a red wrapper with pirate relief. i always paid for it, wasn't so good at pilfering & shoplifting as me brother although i was sometimes his unwitting accomplice - *"go & ask the woman how much this is"* while he stuffed his socks full of top trumps he would sell to me later. but i was also drawn to the advertising campaign showing superman tracking down his evil nemesis *nick o'teen*

or some such bleedin rubbish. i sent off for the poster but it didn't work, just made me think even more about smoking & spanish gold, or the lack of it after we moved to the countryside & england - two huge body blows in one go, big enough to knock me blind & beat me down. they did so. but no one was more surprised at me smoking as a kid, than me. but now i'm sat in a cab in the US of A & the drive sez i can smoke if i want to but hey looky here i'm not smoking i don't have any smokes & i don't want any & if you ask i can honestly say no i ain't got a light & no i don't want one of yours & i don't have to worry about all those wet matches lost zippos & crushed packets of fags & again it surprises me. nineteen years puffing one weed or another & now it's three days since my last ever cigarette stood at the bar getting pisst rotten on good bier at a school prom in thüringer germany. three fat rollies in a row BAM BAM BAM big nicotine hit no filtertip i think i knew then it was the end of my habit. like three times you will deny me & the cock shall crow or at least cough up phlegm in the morning. so simonpeter saltpetre i don't smoke you no more i have stubbed my last draw & as far as i'm concerned i ain't never smoked in my life i am no longer tempted. but i still think about it but like cold, like someone i knew a long time ago has died & feeling like i should be sad but i knew them so long ago that their death doesn't really touch me no more & i'm surprised by that, it makes me feel cold somehow & disappointed with the dissatisfaction of my bland emotional response - *wow, i didn't realise it we i had come to that, well i never...* - that's kinda what it's like. & what's weird is not smoking makes me feel younger than i've ever felt in my life honest to christ life feels better & i'm not needing for something every minute i'm awake & fuck me if i'm not gonna drink to that!

i get back. crack open a bottle of red from the plane. lie in my temporary bed in the heat & the cool white sheets knowing my skin is coated with dry dirty sweat my lungs still clogged with

aeroplane funk my veins still slow from the pressurised flow of sitting getting drunk for eight hours straight watching 'MONSTERS INC™' over & over again giggling to myself seeing them escape the screen & poke from luggage compartments overhead, looking down the aisle & watching twenty different screens simultaneously my eyes boxed with images & reflections refractions & contradictions bent thru the prisms in my specs. remembering the impossibility however hard i tried of establishing eye contact with the guy sitting next to me who *"excuse me"* as he asked me to move from my aisle seat so he & his female colleague could, inexplicably, sidle forth to the bathrooms restrooms toilets bogs &, inexplicably, not return for some time. previously i thought him a pompous home county shite who needed to distance himself from the rest of us by ensuring thru volume we knew he almost always travelled at the very least in business class, but now in the economy crush i have some respect for him. not for getting his end away in the mile high club but for having the decency to keep side with his colleague & not play the man game & meet eyes with me so i could judge his success & share a little bit of the enjoyment of it. nor did he blush. nor she. jezus i would've; wouldn't have touched either of em with yours, believe me.

i lie & drift & drift & sleep. my mind goes BLAH! & *gooooo* & hibbidy. fall out of bed & wake nude full of piss. empty it.

queuing for hours at washington dulles immigration, green forms sticking out of everyone's top pockets, people jostling for space in the sweating snaking back & forth queue trolleys apushing. people tryna barge thru with a *"let me pass! i got a quick connection to catch!"* the two hundred people in front of them answering *"so who hasn't pal?"*. you know the world sees you older when the posters on walls showing 'JOHN TRAVELLER' examples of forms & how to fill em give an age younger than yours. i'm grateful i don't smoke cos by now i'd be gasping.

there were flights missed, but i got mine. sat next to a guy from carlisle en route to his son's, looking forward to fishing on the great lake ontario. he thought i was american; couldn't believe i was welsh. accents sound so different out of context. land on time at 6.30pm. thank the air hostess. straight through the airport. collect my luggage from the carousel. that noise you can hear is my united express this the sound of my taxi, suitcase in the trunk by ten to seven i'm in the yellow cab & the sunshine gorgeous. (big car with no leg room: yellow cab epitome; metaphor for america, her actual freedoms & the perceived fantasy.)

i dunno. how the fuck did i get to the states more to the point how the hell did i ever get out of wales my passport foto the likeness of an algerian terrorist my social significance a splott waste of space. someone's gonna fathom it soon enough kick the door down & i'm gonna get slapt back into place *"you're under arrest pal"* down in the cargo hold a monkey cage back to south wales. ooh-ooh have a banana i'll drink to that.

i lie still, in my bed. partly under the starched stamped sheet. sometimes, sometimes in life, in life, all you need is a chance to give your arse a bloody good scratch; tackle the itch.

i wake. no need for breakfast - replaced by tobacco years ago & now i'm still waiting for the return of appetite. no need for the pseudo addiction of a first thing in the morning tea or coffee now i don't smoke i don't need hot drinks to wash my throat don't need to lift that hot spoon to pour that milk nor moan how you can't get a decent cuppa abroad i have made my life easier. so crack a bottle of water & gulp down. clean my teeth & shower, wash the residue of travel away. dress for the adventure of destination & stride down the hall to the open door & sunshine heat & a fuckoff welsh flag flying outside the

main hall of this campus. *bore da* to you too butt, we have been expected.

with a name like furry hall i was expecting a little co-ed amusement. what i got was an out of term dorm in a jesuit college. it didn't take long to suss the lie of the land. hardly anyone here, but those who were seemed uniformly dressed in dog collars. jezus fuck i don't mean to sound ungrateful but what the shit am i doing in a school for vicars? i musta gone freelance for the gonzo gazette, i should've twigged when i was taking me dump: the graffiti woulda been mild if written on the door of a wendy house in a llandaff crèche. this is going to be excellent. look out laffs, killing field for a one-man ginger group like meself.

meet up with other welsh writers & set off for the local cardiff - my city's namesake; once home to the giant. we find, after double backed after driving passt it, iss tiny. fotograph the church, the road sign, the graveyard & get back to the campus. avoid the opening speech of the conference, crash on the grass in the sunshine. attend the first of the papers & have my fill early of dylan & r.s thomas. experience time, space, perception problems. get back to my room, lie down with aeroplane merlot.

gang-up on the wall outside the hall with the young welsh contingent. we suss each other out & crack open the bourbon - kentucky maker's mark. our number are writers, academics & musicians. the academics are as au fait with ecstasy as enjambment & scansion, which is just as fucking well, for communication to continue. american welsh join us. we discuss the histories, languages, literatures, swansea-cardiff. someone asks if i'm enjoying my stay in the states, i say *hell yes! as i explained to my compulsory mexican dog chiropodist only this morning no one on the planet knows how to stay sane like you guys, & your sense of humour is so insightful.* you had

to be there.

i gess pisst rapidly on a duty free bottla vodka, go downstairs to the common room, crash out in front of the tv & miss england lose to brasil in the world cup quarter finals. wake to find i've lost my spectacles. they show up later in someone else's pocket, only one lens & legs akimbo. i'll fix em somehow.

read the new day in dark glasses. ridden hard & put away wet i wake with a bourbon burp; wake from a dream of a pigeon picking from my teeth, doesn't differentiate between lies & truth. unpack a bread roll i'd saved from the plane - ham & cheese, the international language of cold fast food. take a shower & sort out my toiletries. america is wacky shit. makes my arse bleed, i ask you.

◎

the states is great. it's like waking up with a hangover every day. not an out & out poison residue but a kinda still drunk & everything's ok *hang on a sec, what's that pain?* kinda hangover: everything seems fine like a normal british morning but then you focus your eyes & ears & everything starts getting weird on you, there's something not quite normal here.

spend the day listening to claims to the purported greatness of r.s thomas. *arse* thomas more like it. the free & open mind of the poet beaten up & bullied by the limit & restriction of the religious. the compassion demanded of a priest sacrificed for the self-righteousness of the nationalistic. small-minded explosions from the geysers of insecurity, doubt, self-denial. hypocritical dog-collared cunt in my humble opinion.

the conference focuses on an old wales; one that no longer exists, if it ever did. us sheepshaggers have moved on, it doesn't much matter that no one else has noticed.

mental drift. dylan in a gimpsuit mudwrestling r.s for the title of *'true thomas of the welsh'* or some other valueless pittance. i can see it now... unfortunately. *ych-a-fi...*

◎

saturday nite in armoury square, a few bars & a music store there's little of a downtown experience here. the mall's sucked the soul from this city; the mall where the masses shop-a-doodle-do to their heart's content all consuming uniform global product. miles out of town, the city's heart dislocated, distanced from the central beat. we tried walking, earlier. got within three miles of the mall but couldn't be arsed to go any further. industrial yards, holes in the road that fell to the centre of the earth & ever widening expanses of waste ground. dodgy looking clumps of blokes. people we asked for directions didn't know how to walk to the mall. they knew where they were presently, they knew where the mall could be found, but how do you walk there? *"jeez, i don't know! are you sure you wanna be walking at all?"* called a cab from a truck stop to take us home. shows up driven by an old skinny man, his missus the front passenger, like a real family business. great stoic pair (not bad for an old woman). couldn't understand a word he said, should've put his teeth in. but they got us where we were going fast & cheap, we were grateful for that bargain.

still, we eat & drink skinny with americans at the empire brewery, stragglers together; the few who weren't invited to the official end of conference barbecue, intrigued but not concerned as to why we were left off the guestlist, our mission to enjoy ourselves more than those who were included. continue our nite outside the blue tusk blanking the begging street drinkers, complimenting the local women as they pass to & from dorsey's, then we join them at pj's, home to the little princesses.

our numbers thin. the two remaining talk broadbrush kahdiff. a beautiful young woman leans over (no make up stunning) & sez hello. we *"hello"* back then she sez *"hey, are you guys english?"*. we explain we're welsh & that if she were welsh she'd know we were kahdiff. she sez *"wow, your accents are sooooo sexy!"*. a world first for the kahdiff accent surely, our value greater here than at home obviously maybe we should extend our visit.

a twenty-year-old student. petite & brunette. very pretty, knows it, flaunts it, but riddled with attitude & insecurity. soon introduces us to the possibility of sex at her behest & her quest for a perfect partner: *"you've got a girlfriend at home? but aren't you flirting!?"* - still young for her age, i fail her test without trying. still young but already anti-depressant dependent. her mother makes sure she knows it's the ma who's the beauty. draining the girl dry. probably sleeps with her daughter's boyfriends. the daughter a shadow of who she could be should be, fodder wife for some high wealth college arsehole who's gonna treat her like property, a chattel with breasts beautiful & deep dark eyes. a poor girl hanging out with the rich kids, i send her my best wishes. counselling won't touch her, she needs cultural irrigation; too many people feeding her shite all her life. this is what i hear behind & between the look the laugh & the flick of ash. she doesn't want to talk about it.

she introduces us to her friends. i smell their cigarettes. a nice guy who wants to be her boyfriend but she don't feel she deserves nice men; an attitude laden skinny smoking blonde who ain't gonna like anything except disliking. her posed negativity bores me to death. she's studying literature, drags names out of me, who i've read, who i rate. i pride myself on forgetting names, texts, dates, on freeing up brain space from carrying lists & details. she takes the high road, like i really care what some spoilt little princess thinks of my tastes. i don't

collect information, i absorb or discard. it's a different existence. she brings up the falklands. no shit sherlock, i retort with vietnam, grenada, cuba, etc - yanks can't play this game & win. man we're too been there too drunk having too much fun to waste our lives on silly games & superiority tests with pretty children used to getting their own way. shut up & get the drinks in.

the best way to deal with these situations is to buy yourself a smartarse. i carry one all the time. a little portable foldaway fella, doesn't necessarily get me out of trouble but it does create a suitable smokescreen long enough to check the lie of the land. if necessary, get me out of there pronto. as it happens, the blonde's all pout & no comeback. as suspected, posture & pretence filling the gaps created by an education wasted on the rich; the expectation of her parents. no one else takes up the subject which makes my life easier. i stare at their cigarettes. listen to the music of inhale & heat, differentiate between four different brands, compare blends, watch every millimetre burn complete.

the girls remove to the powder room. the guy informs us the brunette's on a scholarship, the blonde on money. the brunette ain't the brightest but works hard & deserves to get somewhere, the blonde's dumb as fuck but rich & a nice person under all her bluff, honestly. i'll base it on evidence thanks all the same. he talks a fair conversation. take it he's a thinker & straight down the line. fuckit i'm outa here tomorrow, my round again.

the girls come back. there's this long drugs comparison going on around the table; who's done what & what should be done (man the finer points of chemical compounds just don't do it for me anymore). i absorb detail & tone, facial structures & skin imperfections however well hidden, eye colour & the actions of conversation, the women trying not to show too much,

160

showing it all. we drink up & the guy drives us home. we clamber the back seat of the car, i kiss the brunette & get dropped at a hotel. i'm spending the nite in a crack & prostitute hotspot, so i'm told.

◎

i wake in the econolodge. hear the traffic & feel the sun. the sheet way down the bed, the curtains wide open. someone has already been & gone. cardboard fidgets in the hole in the wall where the air conditioning unit should be giving me hum. big red numbers fuzz directions to my glasses placed on the clock. i put them & the tv on. little house on the prairie. all this way for little house on the prairie, leave it out. look out the window, see family members sat on the porch outside a wooden slat house on burnet avenue. children playing, having fun. guess i should put some clothes on. take a shower first. there's a bottle opener fixed to the back of the bathroom door, convenient for lavatorial booze-ups. in one end & straight out the other. grab the econolodge-labelled shampoo, soap & wash myself down. get out. wrap a towel. spot an econolodge pen & pad, scribble something down. a gideon bible cowering next to the bed. a lazy boy chair i wish i'd discovered last nite - could've been fun - a fridge & a microwave, near empty bottles, last nite's threads.

outside the sun is blistering. gorgeous. the freeway offers options to route 690. the fleet building some kinda gothic monolith signalling downtown. i remember seeing a beautiful metal building somewhere off fayette or clinton last nite. architectural shine. the rundown CALDWELL & WARD warehouse opposite. little sparrowy birds bathing in the roadside dust, huge fucking cars great big boxes on wheels with wings & headlites, lincolns & cadillacs i've seen em before but in this town they look different; in this town there's a lot more space, a lot less traffic & people, the roads real wide but

no one to travel. a city in decline.

they said it was gonna be cooler today. it isn't. i gotta leave. pack my shit & check my passport, wallet - everything's where it should be. ditch the dregs of a bottle of bourbon, bottle of vodka, the last bottle of merlot, leave em for the cleaner. keep the litre & three quarters of tawny rum i was given by a virginian, pack that tight, tight as a drum. leave room 118 & drag my suitcase to reception. ring the bell & settle the bill. the clerk tries charging me for calls made by betty. i show him my passport, he says *"you're not betty!"* like i'm tryna rip him off. he calls me a cab, watching all the time, tryna figure why i would pretend to be betty. i grab my receipt & check out.

◎

in a bar at the airport. the asian driver who brought me here only interested in currency exchange - *"i'm visiting london in august"*. i offered good luck. around a dollar 40. *"it's good it's good the economy is good... is that all?... yes sir the economy is good"*. i give him a tip: london's a dump, come to wales.

i'm feeling spooned. pre-noon in a sports bar surrounded by hockey sticks american footballs sport star bubblegum cards. the local team are 'the orangemen' - a bit too 'battle of the boyne' for my liking, can't see me supporting them. i approach the bar:

gimme a heiny please.

"sure. & how are you today sir?"

fine. & you?

"fine. thank you for asking! four fifty."

over & over to every face. i hand a five & walk away.

the first beer so exhausting. get it down. fuckit, drink drink then sleep on the plane. airports bars are boring.

i stroll thru the open plan to the sbarro next door, order myself a parmesan slice. the girl who serves me is beautiful but seems not to notice. i return to my table, slip on my personal stereo, eat pizza, drink beer, watch her work. when there's no customers waiting she sidles over to the magazine stand & fingers the glossies. figures she could achieve this, this here on the page. puts it down to return to her counter & serves two customers demanding service, each thinks they should be first. she chews her gum. bows her head, yawns into her sleeve. continues to be the most beautiful presence in the building.

i listen to the music of my father; the funky love of lena horne, sarah vaughan, julie london & dinah washington & i inherit his potency. i am charming & charged & i am innocent. *"i got it bad & that ain't good"*. i am linked to my father but my charge is different; get my kicks from the buzz & the bounce of attraction & potential love & grind & this is where we differ - i do not want to own nor control i just wanna push their buttons & get mine pushed in return. i had asked other people to listen to the tape. they wore my headphones & a connection was burned.

"roll him over real easy / roll him over real slow". the heat & sweat the demand for sexual activity i am gasping grasping panting & gagging for the involvement the excitement the release. the humidity. something is going to happen today, something with purpose. i can feel it.

the hum of the airport public address is distant, repetitive & demanding. a female member of staff approaches, establishes eye contact & speaks to me. i had been watching her earlier, at

her desk. she's short in heels with long frizzy hair & a smiley face i would like to investigate. i flick between her eyes & watching her lips moving. remove my headphones & say *"i'm sorry?"*, she repeats *"mr. bukowski?"*. i laff; chuckle like a loon, say *"not me!"* smile broadly & add *"charles couldn't make it today, looks like he's gonna miss his plane"*. she dismisses me, turns & searches for somebody else. i'll keep my headphones off for now.

at 12.21 a call comes over saying airforce one will be at newark so expect delays up to three quarters of an hour on flights in & out. drinkers at the bar talk to the barmaid about george dubya, about what a good job he done of bombing fuck out of those *"dirty smelling afghans"*. about how they regret the fact they once voted for clinton. the barmaid sez *"no politics at the bar thank you"*. *"after 9/11 i was so proud... i was glad george was in charge"*. diss clinton. *"please people, no politics!"*. *"oh man his daddy couldna done better & clinton's nothing but a goddamn liberal"*. barmaid: *"now drinking & politics don't go together, you know that"*. *"i know i know but i'm just saying that clinton..."* the barmaid explodes: *"don't you talk to me about clinton! don't you talk to me about clinton! the president shouldn't be the guy next door, he should hold himself high as a moral example to us all we should hold him in a different frame of mind not think of him with that dirty little whore, he stole from us! that bastard clinton stole from us he was a dirty rotten man, a dirty rotten man... but i quite like hilary, she could do a lot for new york..."*.

i drink up. move on to the departure gate. speak to the guy behind the desk, check out the details, settle down & listen in. a group of young soldiers stand at the gate, i.d's in hand but out of uniform. discuss breaking down & cleaning their rifles. they're on a buzz, currently feel they have a value. they retell their accounts of gas chamber practice runs, none of them listening to the others.

◎

my flight arrives in washington, squashed & uneventful. it's hot but bearable. 90 degrees. i catch the shuttle from terminal to terminal, a beautiful blonde woman facing me. mid thirties. i sit behind her husband, his back to me. her magazine reads 'red' it's masthead visible from her soft wicker bag. her coalgrey eyes & mine refocus & zap under the simplicity of her bobbed fringe, her crimson nail polish matches her cardigan's three quarter sleeves & her open toed sandals, a little white flower motif breaks up the crimson on the painted nail of her little big toe on her shapely left foot on her long left leg crossed over her right knee bouncing bouncing & waving my way like a red rag to a/that little white flower an invitation to handle imagine her painting wondering who, today, will look & imagine. lady, you've pulled the ring in my nose, lassoed some dumb taurean. she holds our contact then looks away. this heat is exploding magnificent.

◎

last nite i saw the man in the moon from a back stoop step in syracuse. at 8.32 eastern time i get to look down from a starboard porthole over the atlantic ocean; over a blue wing in deep lilac sky. soon the colours of the moon & sky match. an air hostess smiles, slides down the blinds & hides the nite.

3,669 miles from washington to london, from dinah to julie. three seats away there's a screaming baby. nothing to do but get drunk & giggle; hit the bloody marys, wear a shit eating grin & keep sending out signals.

when she sleeps

& when she sleeps

she hears warpt floorboards creak
feels draught of lift cover
me settling in

sees thru lids lite hazing
peers, smiles
feels me
reach.

& when she sleeps

i read outloud *'trout fishing in america'*
to lull her dreams

she keeps arms under covers
her chin
the quilt
two fists

we meet our cheeks
& warmth sticks

she turns
& kisses

she rolls from me.

uniformly i follow

take up
her space
stretch warm where she's been
allow
no release.

& when she sleeps

in the fleshfolds of nite
where my thumb fits the fob of her concave waist
holsters her gunbelt
my elbow to hip.

& when she sleeps

she tries to turn back to me

i sleep
i flail
rage continuous
or
deadweight

she soothes my outbursts til i too sleep quietly
tho i battle my dreams
she sleeps again
instantly.

& when she sleeps

me
& the cat
orbit her shape

she
radiates

offers
no resistance
to proximity.

& when she sleeps

i long to disturb her
tranquillity

plan to eat gratefully

her

cum breakfast

get over it get down to it jus doan let ya mama catchya doin it doin it i told you that boy doan know what his tongue's for he puts it in places i ain't sure it should go what's he doin with it now that's what i'd like to know...
(stammer rage, for short)

in bed
the two of us
the sheet *just* covering my cock
which rises in direct correlation to my eyes widening
as you promise the lot
offers i would be stupid to not accept...

"if i **K**ould have *-eh -eh -anything?*

"if aye **-K**ould have *--æny*thing...?

"if **-I -K -K -K**ouldav **-ENNY***thinggg!?*

"I'D r**R***R**IPOUT* MY *SSSTU*-PID FFUCKIN TONGUE!!**

&
*bbb***ury it**
in *you"*

...

*'people who stammer
can keep it going for hours'*

169

(*bbb*umper sticker somewhere, surely)

compulse to repetition
(compose to repeat)
com cum pulse to repetish

my little carton of lush concentrate
my little tin of supe *(rrrrr)*
label me
ladle me
fold down
while i *bbb*ite gently
your *bbb*belly
(your eyes)
*bbb*burn my tongue on your
hot love lines
from your SPORRAN OF JOY to my SPASM OF DESIRE
chords *grind...*

my *ddd*ysfluent tongue mutes
you:
 "ooooh, don't speak now"

 all our sticky nuances
 COLLIDE
 make fluid sound
 &
 our *ppp*uddle of love...

tongue tide lapse laps
all nite
all nite

...

armsdeal in adamsdown

i was in the clifton the other nite & some bloke tried selling me
his used PANAVIA TORNADO GR MK1 JET FIGHTER & he
was asking a fair price so i thought: sssuss it out. i walked home
& put it to sal. we discussed its merits & went to bed; went at it
hammer & tongs.

 i discovered:

 skin panelling

 dorsal spine

 hydraulic rudder actuator
 trailing-edge housing
 fuel jettison & vent valve
 tail navigation light

 shoulder pylons
 spoiler housing
 Marconi 'Sky-Shadow' pods
 leading-edge slat rib construction
 front pressure bulkhead
 forward fuselage

 equipment bay
 Kopperschmidt cockpit cover
 engine ventral access panels
 instrument shroud
 intake lips
 double-slot flaps

thrust reverser suction doors
canopy hinge
pitot head
pivot box
her hydraulic reservoir.

she discovered:

two integrated drive generators
twin store carriers
my external fuel tanks

terrain-following tip antenna fairing
laser ranger & marked target seeker
wing swivelling control rod
outboard pylon
control column
cannon muzzle
cannon barrel
Doppler aerial
telescopic pipe
retractable inflight refuelling probe.

we discovered:

vortex generators

intake
wing sweep
root pneumatic seal
heat exchanger ram
swivelling control links
main undercarriage leg breaker struts
inboard pivot bearings

variable area nozzles
flap & slat interconnecting shafts.

hinge point:

head-up display
all-moving tailplane
FIN heat shield!
FIN integral fuel tank!
canopy emergency release
pilot's Martin-Baker Mk.10 ejection seat
ammunition feed chute
rrrrrocket pack!

Sidewinder
penetration weapons
cluster bombs
navigation &
AH! strobe lights!

roger that!

over & out.

system
:
vent.

afterburner
:
duct.

headrest &
FIN attachment

joint...

went back to the pub - all he had left was a HAWKER HARRIER JUMP JET but we was too fuckt for that.

(few pints, a kebab. must've been satdee, aircraft carriers docked by the cashpoint, remembering their pin codes & searching pockets for cards.

eyes right: *"look at the tail on that!"*)

bap-bah!

there ain't much to beat the
reassurance ov the
BOOM BOOM ah! ov ya
nexdoor neighbah's orgaz(jaz)**m-hmm**
cuming thru the wall
reminding you

YOW!

AH!

life go**oohs** on
so why not **GET DOWN!**
(yes!
hammer
&
tongs)
i means:

bap-bah!

they'r gettin it, in'ay?

get on
get on

bang the merry mortar
outa
the other side **ah!**
this wall

bang the merry mortar
out this wall

bap-bah!
bap-bah!

get on
get on...

175

after the refit of the clifton street SPAR

yes the spar on clifton has been well ponced up but still we stand the queue of newsrags & catfood & stella artois as only one of the four new tills is staffed & working. the rest of the staff in their bright red t-shirts follow grannies to freezer cabinets or log returns; dump the weekend broadsheet supplements & shout to each other from till to aisle to till about prices & which to watch dodgy customers. behind me in the queue a drunk breathes on my neck, an onion in his hand & in the arse of his trousers: a frozen meal on a microwaveable plate. i think of: *skimmed milk & rizlas*

spark chamber apparatus

spark plugs,
spark gaps,
gas explosions
retraced by
firefighters missing
out on new highs for
centigrade & fahrenheit, wearing
brass sparables in their ceremonial boots

sparrow grass / asparagus ('spargel' in german).
sparaxis, flowers & jagged spathes. spartina growing in
wet or marshy ground, sparrowhawks swooping overhead

sparring partners & sparing fools, political risings,
insurrection of the spartakist group & the
murder of rosa luxemburg

sparging brews

sparkling wine
& butter-roast sparling,
european smelt & barbecue charcoal

cd copies of muriel spark's 'the prime of
miss jean brodie' or the 1956
leningrad spartito of
khachaturian's
theme to
'the
onedin
line'

(queue remains standing)

porgy
sparoids
relay round
a
spar-buoy, fished for from the spar-deck, sparse net, bugger all
prime tidy

spartans
squeezed
to the toe of the boot, postcards
from
cape spartivento
to
cape spartivento
to
south carolina spartaburg

"i'm spartacus!"

"shut up ya fool, your dinner's sticking out of your trousers".

the girl walking clifton street has sparrowlegs, a silver tray of peking spare ribs from the golden house takeaway & a street of men. jesuswept. this store has three permanently staffed brooms chatting amongst themselves at the magazine shelves. they stop. watch sparrowlegs. the articulation of their wrists & the dazzle of their sovereign rings, the handles of their new brooms already smooth from overuse.

old girl at the front of queue apologises for shaking til she's covered the flush built-in barcode reader with a smasht jar of branston pickle & a spilt bag of salt. with one hand she explains her use of sparine-brand promazine antipsychotics & the parkinsonism entailed as a side-effect, with the other she pockets two packs of B&H.

sparkish bleep interrupts the trance: an improperly loaded till roll escapes, tails like a flare & toots like a steam release. the clayshoot response of several well-placed rapid-fire price-ticket guns restores general peace. the green display communicates, states

'error / this shop is currently hurtling thru space'

so i am delighted, it will soon be my turn for receipt & smallchange. i remind myself whatever happens when i get to the counter: don't speak, cept for *"five packs of blue rizla"*, *"six"* if necessary, & get used to the wait; the wait we had before the refit, remains.

hoover haiku

so firm the suction
so many attachments - *ah!*
empty hamster cage

me lips kaarn geta stiffy

me lips kaarn geta stiffy

but they can bulge at the taste of swell with the touch of
of your of your
amoeba lips
your cherry lips
your vino calimari lips
your mushroom prawn in garlic whitewine sauce & thincut
parma lips
your gelatino surprise lips
your cooking lips

your
let's eat! lips
have a meal lips
your book a table phonehook lips
your fuckable lips
your *fuckoff* lips
your *ang ona mo* & laffing lips
your cheese on toast ya garlic salt ya sat infronta the telly lips
your semolina jammy lips
ya goldenlion syrup lips
ya hot porridge lips

your winterwoolly homemade lips
your greeneye lips
your rosy lips
ya orangeglow in snowing lips
ya steaming lips
ya moving lips
your epic nuclearwinter lips

your lips signing off like a klaxon your
lips like an
air raid siren

your
sk- sk- datsun cherry lips
ya postbox lips
ya respray ringing auction lips
ya suction lips
erection lips
your red tender taut hose lips
your

pull the cord
hips
your

stripping lips

<div align="right">

ya climb the lips
eiger mont blanc snowdon lips
K2 kanchenjunga lips
andorran lips
ayers lips
your tours to the top high altitude lips
your sands of the serengeti

</div>

ya goat's cheese lega lamb lips
ya meateating veg & mintsauce lips
ya kosher lips
halal lips
ya kebab when shitfaced pisstup lips
extra double portion lips
your *stick it all on*
ya chilli sauce lips

mexican lips
peruvian lips
your llama spitting chile lips
patagonian argentinian lips

all at sea

your melting matelot missile lips
your south atlantic conflicts
amazon antelope alacrity
ardent active avenger
arrow
your 21 lips
your purdey
your ambuscade
your exocet range
your mercy

your burntout lips
your beauty

your
lips of lemon
lips of almond
lips of olive oil
your
lips of the soil
lips of the land
lips of this land i love
your
lips of the sky above
your

eye of the storm
your satellite of love
your lou reed or nico

your lord above
your coffeeshop trips
ya big balou hits
ya yogi ya boo boo ya jellystone blips
ya *uh-o! officer dibble lives!*
ya *see ya tc*
later
lips

ya gargle wi tcp lips
ya medicinal lips
your bad breath & indigestion

vesta lips
noodle lips
just add water cheap curry lips
fart in the nite duvetshuffling lips
your law- wind- circuit- breaking lips
ya cometary tail

 galileo lips
 your telescopics
 ya parkes ya hubble
 observatory lips
 your latitude longitude
 cosmic lips
 probing lips
 your discovery

 your lost in space little girl smile
 your lips of invasion
 lips of bacteria
 your virus lips spiralling down
 ya meteor hurtling towards us like a fireball outa the sky

 lunarlips on a shuttleservice

your huge step for man no mention of woman venus lips
mercurial lips
martian jupiter saturn lips
your neptune lips
your pluto lips
uranus

black hole
white dwarf
your panic on every continent
your calming sense of inevitable sensational freefall inta the
sun

sky lips
satellite links
your interstellar receiving dish
we interrupt this message lips
you see on screen your countdown lips
your presspass outside broadcast lips
ya live from the scene
your
land in the sea
your flag in the earth
your
visitor's lips
little green lips
your official denial & roswell lips
your witness lips
your implant lips
your sands of time & cigarshaped lips
your saucer lips
signal lips
your buggy fulla rocksample moon
your lips coming at us from a different dimension
your re-entry groove

your mushroom garlic butter lips
your calimari

hmmm.

ya milky lips
ya filter tips
the world spun around by your teaspoon
your intercontinental ambassadorial tongue
encourages the rise of my tower of babel

it's your
language lips
ya wenglish lips
ya german russian spanish lips
assyrian chinese hebrew hieroglyph & classic latin lips
ya cyrillic
ya arabic
bengali telugu
your japanese lips
greek lips

religious lips
catholicks
devoted fundamentalips
your orthodox
pure hedonist
angelic vampiric cunt

your blood
in my throat
your grunt of love

giggle lips
pillow lips
your chasm spasm orgazz lips

your box of tricks

your pissdribble lips
ya *didn't mean this*
ya pisst lisp

your nibble on the edge of existence

dark lips
shadow lips

your heard it all befor
lips
your young & never been kisst
lips
your who you tryna kid
lips
your old dog
lips

red hot flare up match head lips
pushbutton self-destruction

your
lips of cherry
lips of fire
lips of planets
lips of liar

CHEAT!

your lips of
deceit

your
lips of pleasure
lips of treasure
lost lips

beached lips
middle of the ocean lips
your sea
your blue as far as the eye can see
your blue above & between

 your
 parrot parchment pirate lips
 plankwalk mutiny bounty lips
 flotsam lips
 casta lips
 crusoe palmtree sand dune lips
 jungle lips
 adventure lips
 ya sleeping on the coast of an indie

your
diary entry

your
lips telling a different story
from any other day of the week

lips!
speak to me!

 your
 multimedia expo lips
 advert lips
 freesample lips
 ya billboard brochure flypost lips
 labia all over the world
 ya covergirl

 your
 bikini lips

kinky lips
inkypinky scorchio lips
your dive for pearls

your what's it all meant to mean
your benevolent freakout scene

your
carer lips
social lips
mental health & prozac lips
hunted haunted flaunted lips

your lips of resolution
your lips on the streets of despair
your lips on a streetcar named desire
your lips in a hot poker stare

you're a

LIP'S LIP!

a telly lip
a fotofit
a pullout poster frontal lip
adult lip
brownpaper lip
backseat risk it quick
lip
angel of absolution
lip

hot universe flesh

your
sunshine lips

cornflake lips
popcorn kist your summer lips
fresh northern lites on the windowsill lips
sssssmmmoking

vision lips
peacenik lips
quell the quiet riot lips
tantric t'ai chi meditate & *rrr*each your innerbeing lips
lips of one's innerself
lips on the
highest shelf

shining armour white charger lips
bend down & scoop nice & safe lips

 your horse's arse

lips into the sunset

hand in hand lips
no longer one above the other together yet apart lips
parted
lips
pouting
lips
asking question question
lips
asking asking question
lips
question
lips
question
lips
question answer question
lips

lips in a
rrrrrrrrrrrrrrrevolution
lips in a swell solution of sensory haste
dribble of taste
of your

 of your

 of your

 of your

 of your

 of your

 of your

 c
 o
 m
 m
 u
 n
 i
 c
 a
 t
 i
 n
 g
 .
 .

bbboing!

imagine
(hey! ain't that title been done already?)

imagine after bill haley someone sez

> *"presley, that rock'n'roll kick's been done already"*

or to little wonder stevie

> *"boy, ray charles got copyright on that blind black*
> *piano playing"*

or waltzing way back to the three brothers strauss who - fair
do's - were new once themselves & sez

> *"what's the point kindred?*
> *none of you'll hold a torch to your daddy"*

saving us the efforts of eduard, josef & (notably) waltz king
johann the second

or while we're in that century to adolphe sax

> *"man, we got enough reed in this pit already!"*

later, to coltrane

> *"son you ain't bird so quit tryin"*

to diz

> *"you learnt from eldridge, sling it gillespie!"*

to miles

"you ain't diz, we ain't buyin…"

jump a few years to robert nesta marley

"you were heavily influenced laddy"

twitch & switch to those who learnt the moves of nijinsky, nureyev, nellie kim, korbut, comaneci, a cruyff turn, a john charles head, a karpov or kasporov defence

"now you KNOW that ain't the first attempt!"

do you think this skill, insight, beauty, experience, exploration, pioneering discovery should be left for D for dead?

"it's been done before! so never again!…"

well now imagine poetry - POET*reeeeee* - according to the way we speak: the art every human expression aspires to be - *"man it was so pure so good so right! it was righteous poetry!"* - imagine poets saying to each other

"son that phrase, that musicality, that structure, that typography, it's all been done before. you ain't nothing new now nor you gonna be, stick to the mathematical score of diabolical disciplined verse patterns & sonnetry, enough of this you're way off key, no more!"

like we never had the twentieth century

wouldn't it confuse the bones of you?
wouldn't it steam your substance into balls of heat & despair?
wouldn't you turn temples in search of sanity?

jeez!
it does me!

say that again?

 "it's been done before"

by you? NO!? so sue me!

heesh...

...hey

i ain't saying i'm ever gonna be ever gonna be as relevant as any as any of these aforementioned characters of quality Quality QUALITY but *scuse me! scuse fuckin me!!!* i ain't elvis nor haley, ray charles, little stevie, inventor of instrument nor waltzist, jazz giant, skankin sir, gymnast nor maestro of movement tactic strategy, surrealist, dadaist, creator of accent dialect linguistic originality, will carlos, burroughs, kerouac, olson, black mountain, *but scuse me if i just go burn my fuckin bollocks trying to keep those found territories going!*

in my own little way.

hmm...

you gota *woooork* with it. work in it work thru it work thru to get to their something tread their steps to see where they're leading

am i making sense here?

(surely!)

to stick to the old path leads us

WHERE?

WHERE?

WHAT!!!

WRITING SONNETS???

(give me strength)

you are surely certainly preposterously fuckin joking!

the sonnet is dead, this is expression we're talking... .

(a-re-bop, a-re-bop, give me strength, fuckin jokin...)

bring it on...

kurt works

**krestfallen kurt reaches K
in his kard kollection...**

krestfallen kurt reaches K
in the premiership...

kerr.

ker**RRRRRAGH**.

kerr kinkladze kanu.
kerr kinkladze kanu keane kach*looo*oul.
kerr kinkladze kanu keann*ne* - (k)*neen*-a - kiely - kerney - kanu
konschesky kaNOUTE.

korsten.

korsten kell.

el khalej killen kinder!
el khalej killen kinder kanoute!
killen kinder kachloul!
keown...

ke-ₒ°ᵒᵒⁿⁿ wnah...!

kearns kanu...
knowles kanu...

KETSBAIA!

KINSELLA!

KELL KERR KANU!

¡Kerr Rrrumm!
¡Kerr Rrrumm!

KELL

<u>KERR</u>

KANU?

KURRRSCHHHKURRRSCHHHKURRRSCHHHKURRRSCHHHKURRRSCHH

DA

RRRSCHHHKURRRSCHHHKURRRSCHHHKURRRSCHHH

DA

kneipengespräche (pub talk)

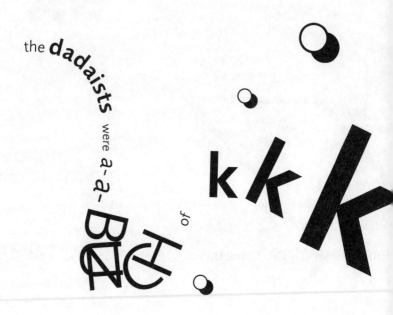

the **dadaists** were a-a-BACH of kkkk of

kunst...

achtung!

i speak with a stammer. i don't care how you refer to me
i speak with a stammer.

in 1997 the british stammering association issued a statement
to members notifying us of the adoption of a 'mission' or 'vision
statement' around which the association wanted to focus its
money, efforts & influence. the statement the topbrass agreed
on was:

> "a world without stammering".

this was their vision; this the proposal put to the members. an
aim. something to fight for. a banner under which we could
enlist support for 'our' cause. a cause they reckoned to be the
the the eradication of stammering.

no mention of education. no mention of knowledge. no
mention of breaking down prejudice nor tackling barriers. no
mention of stereotypes. no mention of supporting existing
stammerers/the existence of stammering/promoting so-called
dysfluent speech to the measly realms of normal human
activity or behaviour. no mention of realigning the generally
acceptable definition of normality to include people like me. no
mention of communication, tolerance, community, or the
empowerment of individual. no mention of positive speech
therapy or taking our rightful place amongst the masses.

this person is stammering. right now this *ppp*oet is
*sssssssssssssss*stammering so what *so fucking what* so tell me.

so i communicated. i asked what the fuck they were thinking. i returned my brown shirt still reeling in the interest of freedom of

& my right to speak natural; dysfluent...

Achtung!

the b.s.a is listening to you!

my friends

provided you learn how to how not to use mock-pseudo-
fluency techniques avoidance tricks
provided you learn how to
sssssound *sssssound*
more like them than me
them whose ambitions are 𝔐𝔞𝔰𝔱𝔢𝔯𝔰 𝔬𝔣 𝔉𝔩𝔲𝔢𝔫𝔠𝔶
(altho there's no absolute - reality)
how to how not to how to learn how to pretend to
how to how to be one of **YOU**
how to how not to
how to speak & utter the phrase & appease & offend
with our tedious fucking plosive prolongative
bad blocking breath & 'self-imposed' prerogative
to
keep **THEM!** waiting

get on with it!

(slow down keep calm slow down keep calm)
but fear not
the b.s.a brothers in arms have seen the lite & will
bid for you to keep **US** quiet! or rather:
eradicate...

thththththththththththththththe
;() ;() ;() ;() ;() ;() ;() ;() ;() :BBB :BB :B!
esse
;() ;() ;() :/ :- :- :/ :- :- A!

luhluhLISTENS! tuhtuhtttttuhyuhyyyouu...

well, i have a message too:

thththe **BB**.essssse.**A** *is* listening to you
so speak slowly & clearly
or
fffffffor::::: : : ; ; : fffucksake

shut ya neck!

& keep

SSSSSSSSSSSSSSSSSSSSSSSSSCHTUM!

(sssssssssss s sss ss sssss sss ssss ssssounds like
ss ssssss ss ssssss ss ss s sssss ssssomeone's
ssssss sssss sssss ssssssssssswitched on
*ththththththththuh **G GU GUH***
GAS!
ssssssssssssssssssssshower
again..............

hmm.)

planecrash loose haikus (3 of 6)

planecrash loose haiku

bbbeing
bbboeing
bbboing!

planecrash loose haiku
(non-plosive west country conversational mix)

e - i
o - e
o - i

planecrash loose haiku
(lloyd robson performs)

bbb-
bB-bB-bB-
bB- fuckin - *bB-bB-bB-* ang on a minute - *BBB-*

*bbb*eyond burroughs

"now i got all
the images of
sex acts &
torture ever
took place
anywhere

"and i can
just blast it
out & control
you gooks
right down to
the molecule

"i got orgasms "i got screams

"i got all the images any hick poet ever shit out

"my powers coming!

"my powers coming!

"my powers coming!

"

(from 'nova express' by william s burroughs)

215

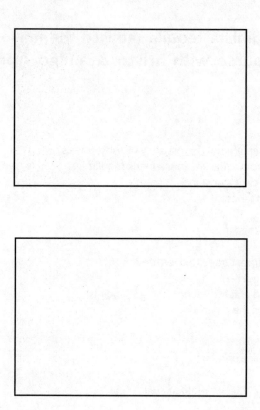

beyond burroughs, beyond...

sandinista tequila tabasco the mayor go 3-course with aristo & amigo from el real

chillipep *ah!* hot defrost *ah!* yellowbox meals
cashcrop equat *ah!* sowta merik tequile
salt & citric gunship
splash tabasc
o!
combat gear.

back throat gone to overthrow
nost- guer- ril
coup d'état red as *the clash* go sandinist
blue as the argen
steer.

the voice of revolt

 all our mothers' tears

aztec volcay *no!* erupto toot sweet

 aristo! my arse bleeds!

aristo one unfunny gringo
 (we owes you compadre)

black shades - green beret - defoliate fields

 he wants heat i'll give him heeaa-sheeit!
 get the vatican mucho quick!

(saints bless this
unholy ring)

aristo & amigo turn the flame on el fugitive;
the mayor outside in...

splash

i.

o one meani
d in languag
which enable
sense of sel
f interpreta
can have no
s major impl
possibilities
r, that

ii.

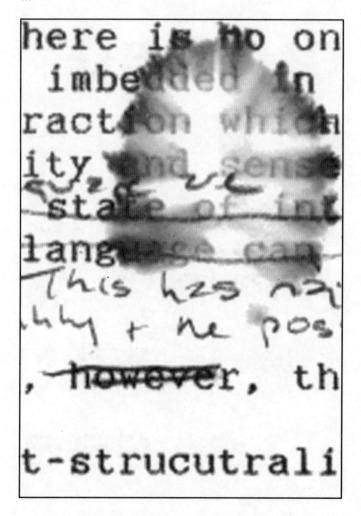

here is no on
imbedded in
raction which
ity, and sense
state of int
lang
This has na
hly + ne pos
, however, th
t-strucutrali

iii.

cussed
d where
se conc
e way w
underst
is see

222

iv.

v.

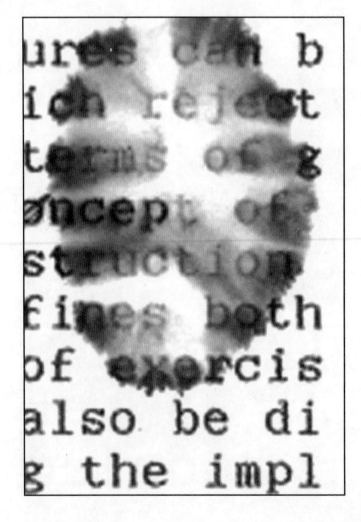

ures can b
ich reject
terms of g
oncept of
struction
fines both
of exercis
also be di
g the impl

vi.

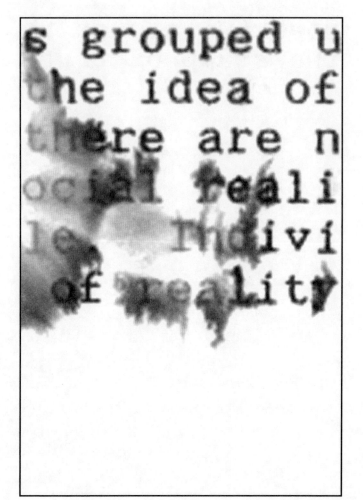

s grouped u
he idea of
there are n
ocial reali
le individ
of reality

vii.

powerful groups th
the stamp of truth

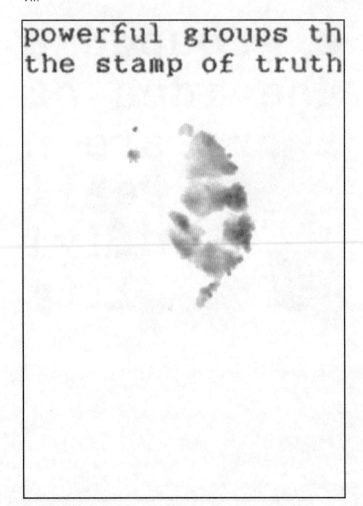

independent

Therefore,
intimately
lived out i
interest of
and not oth

POWER

ix.

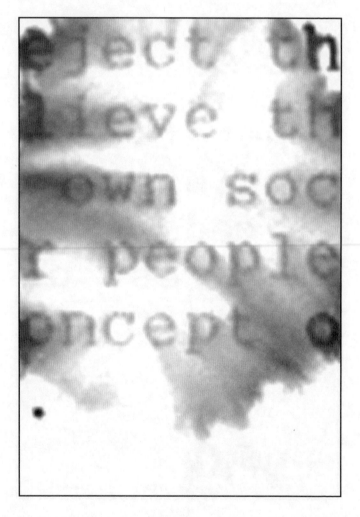

language notes

introduction:

this text is based on a talk first given to the newport central (teenage writing) group, newport central library, john frost square, newport, wales, september 1999.

every effort has been made to acknowledge the use of other writers' work in this text, but to any writers whose works i may have unwittingly assimilated: i apologise & pay respect & compliments.

language notes:

language can take on a life of its own & be interpreted differently by everyone. no two people will take it to mean exactly the same thing. so what we must do with language is go behind the scenes. words only mean what we think they mean. a dog is not a dog, a dog is something bigger which we call a dog. this is the truth - but there is no truth. people see different sides to it. think of the game chinese whispers as an example of how language can be controlled or mutated to tell a story in a different way; to take 'the truth' & create another truth without overtly using untruths.

we create ourselves through language; the meaning of things; how we interpret our experiences. we're born into the language, it exists before us, so we expect to have to fit into a framework already in place, but OUR interpretation of language & our articulation of experience EVOLVES the language as it does with existence, with society, with culture/s.

but the people with the power to control or create language influence how other people use or understand that language by developing or strengthening GENERALLY ACCEPTED or DOMINANT meanings or definitions. whether for good or bad, by poet or media mogul.

an example:

the people in power have redefined the meaning of the word 'unemployed' so we as readers, viewers & listeners, tend to rely on the GENERALLY ACCEPTED or POPULARLY PORTRAYED definition of what that word means, or implies.

not only have the people in power redefined what we accept the word 'unemployed' to mean, they have also redefined our actions or responses to people who are described as or labelled 'unemployed'. this influences how we perceive the people involved. if enough politicians, journalists & big mouths tell us unemployed people are only unemployed because they are lazy, work-shy, too stupid to get a job, unreasonable, unreliable, pathetic, fat, smelly, ugly, shady, in possession of a criminal record, dangerous, or even from liverpool, we will believe it. they have created in our minds a status or ranking for people who are described as 'unemployed' & once this is defined we are encouraged to attach moral judgements.

this is only an example & an obvious one at that. i could have chosen 'overweight', 'intellectual', 'teenage' or any from a million or more.

this influence happens. it is real. this is one of the ways in which language works, or is made to work. people get labelled & often these labels can condemn us for the rest of our lives. they influence those people who use the language of labelling against others; they influence people's actions & reactions towards those who are labelled; they influence the actions &

reactions of those who wear the label, encouraging them into acting the rôle, into becoming the stereotype.

so we are defined. as people we are defined; given status; given our set ways of practice, our rôle, our behavioural model. if we are told enough times we are 'bad' we will act 'bad'. we are influenced by what people or media tell us. sometimes consciously, sometimes not. this control over how we behave is not actual, we are not put in chains, but it is control through influence & this influence is exercised through language.

language is the most common & basic form of conditioning, strait-jacketing, brainwashing or thought control. call it what you will.

an example:

if i brought another adult male into this group & told you beforehand he had spent time in prison for killing a man it would dramatically influence how you perceive him, react to him, treat him. however, if i brought him in & introduced him as 'my mate' you would probably act in a completely different manner. this difference in how you think, act, speak, is perfectly natural; it is defensive & often sensible, but at best you would be judging him on one action out of millions of actions which had taken place throughout his life, or at worst on mere hearsay.

however you react to the information, i would be the person in control. not you, not him, but me. why? because your reaction would probably be standard; you would more than likely process the information & decide he was by definition 'a murderer' & as such would probably react in a set number of ways, even though i didn't actually state there was anything unlawful or malicious in his actions (i implied but i did not state), & you would have no evidence to substantiate my

statement as truth.

what i did, in giving you this information before you met him & by implying further information, was PRE-DEFINE YOUR REACTION to him. i decided how you would react to him (or at least narrowed your options) by describing him in a certain way. i LABELLED him knowing you would probably react to the label & decide, based on stereotype, how he deserved to be treated; you would decide what sort of person he was based on a mere snippet of information, the truth of which you had no way of knowing.

another example:

some people are labelled as having personality disorders simply because neither we nor they understand why they act or think in certain ways. in reality this is because we, as a society or culture, don't actually know what's wrong with them, if anything at all, because THE LANGUAGE DOES NOT EXIST in which one side articulates their condition, the expression of their existence, & the other side understands what that articulation represents, what it means.

so on one level, these people we refer to as having personality disorders are born into a world where they don't exist, because the language in which they can articulate their existence does not exist for them to be born into; it does not pre-date them so it isn't there for them to use.

basically, the order of the process is:

. the language
. the thought
. the thought articulated.

if the language does not exist how can someone have the

thought, let alone articulate it? stop & think about this. how can you process thoughts without words?

as i stated earlier, what we need to do with language & its usage is go behind the scenes. what is presented is not the only option available to us, but for options we have to go looking, they will not be offered, you must hunt them out.

a theory:

> *"where there is power there is always resistance*
> *or potential for resistance & potential for resistance*
> *to be successful & bring about change"*

> (foucault, 1972; bastardized by robson, 1999).

human existence is evolutionary-based. our whole existence is about survival, about making survival easier, about bettering ourselves, furthering the developments & extremes of ourselves as individuals, societies & as a race. for some reason there is a very strong desire within every human being to prevent change as well as promote it. sometimes this is good. sometimes it isn't.

evolution = change = growth.

as individuals we change, as societies we change, as a race we change. so why not our language & our language usage also?

> *"those with power can control the language of*
> *the discourse & can therefore influence how the*
> *world is to be seen & what it shall mean. language*
> *promotes some possibilities & excludes others; it*
> *constrains what we see & what we do not see...*
> *modern power operates through the construction*
> *of new capacities & modes of activity rather*

> *than through the limitation of pre-existing ones...*
> *power, according to foucault, ...produces*
> *realities & truths"*

<div align="right">(howe 1994).</div>

this quote refers to 'discourse'. an acceptable definition of discourse could be:

> *"a set of meanings, metaphors, representations,*
> *images, stories, statements ...that in some way*
> *together produce a particular version of events"*

<div align="right">(burr 1995).</div>

language is a part of the discourse, a discourse that includes symbol & colour. it's a language which includes the words that enrich, that seep from nooks & crannies; so-called obscene or blasphemous words, slang, dialect, terminology, phraseology, even grunts & fillers (ums & ahs), & structures which mirror natural & unnatural thought processes & verbal output, rather than logical sequence.

language isn't limited to words & structure, it's also accent, pronunciation, punctuation, tone, tempo, musicality, fluency, eye contact, body language, gesture, impediment, etc.

so who controls this discourse; who controls language & its usage; who are the people in power?

well, any of us, potentially. everyone has the power to control language & how people act or react to that language. power is exercised through language, so power is available to everybody who uses language. therefore, we can all stand up for ourselves through language against those trying to enforce their own perceived power over us, by challenging not only

their language but also their usage, their definition of language; to attack, counteract, outwit; to defend ourselves & the people around us; to widen the territories of language for the benefit of everyone, for the benefit of communication.

as a rule those who have most power are those who have influence over how we communicate; over how information is communicated to us, as individuals or en masse. these people include politicians, royalty, those who are perceived to be or proclaim themselves to be our superiors or of a higher class or standing, the media, artists & writers, even our friends, lovers & family. language is controlled, for example, via party policy, dogma, religion, philosophy, fashion, the enforced 'norm' (eg. the 'queen's english'), censorship & even by something as simple & personal as tone of voice.

but individual voices who are not under the controlling interest of large organisations such as governments, corporative media & religions, or society's current mores, pose a very real threat, as they threaten to develop language & our ability to communicate in directions leading away from where those organisations want us to go, & if language develops then the means for us to think & express ourselves articulately, to claim control over our language & instigate change, to reclaim power over ourselves & our ability to communicate what we really want & what we really feel (rather than what we're told to want & told to feel), improves massively.

throughout time, poets & other writers have been rounded up, arrested, detained, incarcerated, executed, either without trial or on trumped-up or irrelevant charges (blasphemy, incitement, obscenity, etc) because they have been seen as a threat to those in control. russian poet irina ratushinskaya, speaking at the 1998 wessex poetry festival, described her arrest while a student in russia & her subsequent imprisonment in siberia. she was arrested because she was a poet. she was

not a radical per sé, nor was she writing inflammatory, anarchistic, or 'western' texts; she incited no one to riot nor go over the wall. what she did was write poetry. for this she was arrested.

today, these activities still continue throughout the world. the development of language & articulation is still a threat. individual voices working outside of regimented organisations are still perceived as being disruptive towards the established & tightly controlled channels of communication, channels that may travel, for example, from government to government-influenced media to the people. so should not a poet, by nature, be some kind of a danger to the control of language & its usage; a loose cannon; a spanner in the works; a threat to those who want to control our articulation?

now i'm no academic, but i believe poetry to be the laboratory of language, so surely to be such a loose cannon is the natural state for a poet, to exist outside of the systems of control over language, or at least to push towards the boundaries of that control from inside language's present usage? ultimately, as writers & as human beings, shouldn't we strive to create the language in which we can articulate our, OUR individual existences?

language is an instrument of expression. it is unjust of people, including writers, to attempt to restrict a person's use of language; a person's ability to express their self or articulate their existence; to force others to squeeze into the slim confines of their own or their society's communication limitations. so whatever the direction (providing it's away from the safe, well-charted & overdeveloped centre), surely the continued evolution & revolution of language should be a driving force for writers, especially those who dare call themselves poets?

splash goes kolor

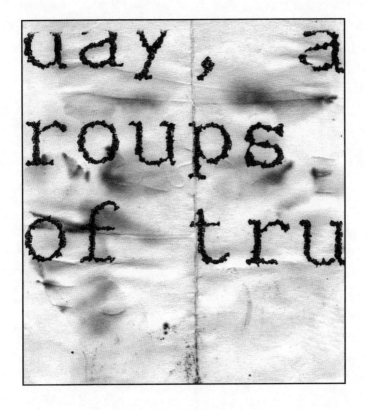

glossary

here's a list of dates & references. you can refer to it text by text as you work your way through the book, go through it all in one go, or ignore it completely - it's up to you boss, it's your book, read it how you like. some of it may seem like i'm stating the obvious, but it all depends on your personal knowledge base.

a. crash

newent (1997)

torvill, perfect 6, double axel
allusions to ice dancing & skating. jayne torvill, medal-winning british ice dancer; perfect 6, the highest achievable score from any one judge; double axel is a jump (axle, of course, is a piece of car)

cwtsh
commonly believed to be cymraeg but probably welsh dialect (possibly the south-east wales gwent dialect), equivalent of... well, difficult to define. in my vocabulary it is a noun (& verb) referring to a secure, protective or reassuring hug, such as a child may demand of a parent or may be offered to a adult who feels vulnerable. it can imply a lovingness &/or a desire to care or protect. in this sense it seems to have a more profound emotional resonance than 'hug' or 'cuddle'. alternative definitions include a verb meaning 'to lie down' (for sleep, warmth or protection) & a noun referring to a cupboard under the stairs or a deadend. there is a smallness implied by all definitions

bosom angle
an angle between strut & leg of an electricity pylon

stanleyblade
a box knife

triplex
a brand of safety glass used in car windscreens

michaelwood (1997)

michaelwood
a service station on the M5, between bristol & gloucester

battenberg
slang name for a traffic police car, based on its two-colour design reminiscent of the marzipan-covered sponge cake

desertstorm
following on from operation desert shield, operation desert storm (16 january - 27 february 1991) was the second phase of the persian gulf war, waged in response to iraq's invasion of kuwait (2 august 1990) after iraq accused kuwait of stealing from the rumailia oil field. although there were many nations involved in the warfare against iraq (afganistan, australia, bahrain, bangladesh, belgium, canada, czechoslavakia, egypt, france, germany, honduras, hungary, italy, kuwait, new zealand, niger, oman, poland, qatar, romania, saudi arabia, south korea, syria, the united arab emirates, the UK, the USA - source: www.desert-storm.com), it was the bomb baby of american president george bush & his senior staff. many wondered if they would've been quite so determined to strike had kuwait not been an oil producer. desert storm consisted of a four-day ground war following relentless air strikes. footage of these air strikes was watched with amazement, bemusement, horror or glee by the military personnel & goggle-eyed citizens of the western world. in many ways this was the first ever example of human slaughter serving as live televisual entertainment. didn't we just lap it up

totem
the tall sign advertising fuel prices outside most petrol stations. they sometimes house mobile (cell) phone masts

visual images
the visual images in this work are original creations based on photographs from the gulf war. as such they are elements of an original montage. however, details of the remarkable photographs on which they are based, are as follows:

frame one: USS john f. kennedy at sea. the original photograph was published in 'military lessons of the gulf war' by bruce w. watson et al, greenhill books/presidio press, isbn 1-85367-103-7, © unknown

frame two: f-4g wild weasel aircraft armed with HARM missiles. the original photograph was published in 'military lessons of the gulf war' by bruce w. watson et al, greenhill books/presidio press, isbn 1-85367-103-7, © unknown

frame three: cockpit. the original photograph was published in 'thunder & lightning' by charles allen, hmso, isbn 011-701-625-X, © ministry of defence

frame four: f-4 phantom armed with HARM missiles. the original photograph was published in 'the sunday times war in the gulf' by john witherow & aidan sullivan, sidgwich & jackson, isbn 0-283-06110-3, © christopher morris - black star/colorific

frame five: cruise missile over baghdad. the original photograph was published in 'the sunday times war in the gulf' by john witherow & aidan sullivan, sidgwich & jackson, isbn 0-283-06110-3, © sipa/rex

frames six & seven: the destruction of a bridge over the tigris,

video shots taken by french jaguar pilots. the original photographs were published in 'the sunday times war in the gulf' by john witherow & aidan sullivan, sidgwich & jackson, isbn 0-283-06110-3, © gilles bassignac - gamma/fsp

frame eight: tornado f-3 & pilot. the original photograph was published in 'the sunday times war in the gulf' by john witherow & aidan sullivan, sidgwich & jackson, isbn 0-283-06110-3, © steve bent/katz pictures

frame nine: f-3 tornado over kuwait. the original photograph was published in 'thunder & lightning' by charles allen, hmso, isbn 011-701-625-X, © peter march

frame ten: distress following the death of 314 civilians during the bombing of the amiriya building, baghdad. the original photograph was published in 'the sunday times war in the gulf' by john witherow & aidan sullivan, sidgwich & jackson, isbn 0-283-06110-3, © unknown

UK, texaco, Q8, Esso, JET, Mobil, BULLDOG, BP, Anglo, thrust, POWER, imperial, ACTION, LittleDavid, PRONTO, BFL, 3D, H, SF, BRITISH BENZOL, REPSOL, ELF, Shell, AMOCO, Gulf, TOTAL
brand names of petrol producers, retailers & petroleum products

ALLSTAR, Agency, OVERDRIVE, AMERICAN EXPRESS, Access, MASTERCARD
credit, charge & fuel cards advertised at many petrol stations

NEXTDAY
parcel delivery service

tuppence
two pence. incidentally, tuppence is also a euphemism for the

female genitalia

blim
a tiny piece of cannabis resin, usually the only remaining miserable little piece of what was once a bigger block

rizla
brand of cigarette papers

skins
common or garden drug slang for cigarette papers

cunt (& variations of)
sources: 'a dictionary of obscenity, taboo & euphemism' by james mcdonald (sphere books, isbn 0 747401 66 7), including quotes from 'science of chirurgie' (lanfranc), 'the spanish curate' (partridge), 'the virgin martyr' (massinger), 'the miller's tale' & 'the wife of bath's tale' (chaucer); the oxford english dictionary

cuniculus
rabbit

trunky wanna bun?
specifically, a question aimed at someone who's listening in on a private conversation, the implication being their big ears are flapping, the suggestion being they go away. generally, a statement aimed at anyone you feel is involving themselves in something that's none of their fucking business

west mercia
regional police force for the english midlands

jamjar
rhyming slang for police car

sainsbury's
british supermarket chain. specifically, the branch on the
outskirts of plymouth

tour notes (& comic titles) (1997)

tour notes
big big thanks go to the now disbanded britpop band 'reach'
with whom i had the grand pleasure of performing
occasionally, both in the UK & on tour in germany. although
this text is based on the 1997 'reach' tour of germany, it isn't a
historically accurate document & should be considered a piece
of fiction. if you ask the boys in the band they'll tell you it didn't
happen like this, exactly

comic titles
the phrases shown in upper case are titles from 'battle picture
library', 'war picture library' & 'commando' war comics which i
read fervently as a kid & which, until she told me to shift me
junk or it was going in the skip, were stashed in me mam's attic

thüringer
or thüringia. a central-eastern region of germany. before the
fall of the berlin wall & the reunification of germany, thüringer
was part of the communist GDR (east germany)

action man™
a military action figure toy

bier
a german drink - go figure

photographs
images from the original tour on which this fiction is based, can
be seen at www.lloydrobson.com

rawhide
a reference to a scene from the 'blues brothers' movie & the
title music from the tv series 'rawhide'

giro
british welfare cheque

jessops
high street photographic retailers

bitte
deutsch language equivalent of 'please'

nein
deutsch language equivalent of 'no'

fünf
deutsch language equivalent of 'five'

tschüß
deutsch language equivalent of 'tara', 'bye', etc

sky news, the space channel
satellite tv channels

ccfc
cardiff city football club

schwitters, ursonate
see the glossary notes for 'kurt works'

rangers
one of glasgow's two main football clubs - both are renowned
for the religious bigotry of some of their fans

danke
deutsch language equivalent of 'thanks'

bitte schön
deutsch language equivalent of 'can i help you?'

prost
deutsch language equivalent of 'cheers'

thüringer rostbrätel
tasty regional dish of meat & mustard

cain
barbara cain, the typographer who designed the layout for jean cocteau's 'die geliebte stimme', © 1982 gustav kiepenheuer verlag

stasi
the internal security force of the former GDR

ryan giggs
famous footballer born in cardiff

the jam
british punk/mod/new wave band (1977-83). 'tales from the riverbank' is from the album 'snap!' (1983)

sexus
a novel by henry miller; the first of the rosy crucifixion trilogy

ja
deutsch language equivalent of 'yes'

frau
deutsch language equivalent of 'woman'

carry on
a series of british films that relied heavily on innuendo, camp &
toilet humour, & were often set in camps of one sort or another

harold lloyd
american silent movie actor. the promotional photos for the
film 'hot water' (1924) show harold lloyd sat in a car stuck on a
tram line, surrounded by disapproving passengers

arschloch
deutsch language equivalent of 'arsehole'

number one
a basic haircut, shaved down to the bone

gott in himmel
deutsch language equivalent of 'god in heaven' - the sort of
exclamation you'd find in old british war comics, as in *"gott in
himmel, is there no stopping these brave tommys?"*

autobahn
a german motorway

overload once more
lyric from the song 'overload' by reach

a manhattan montage (2001)

the shanksville plane
united airlines flight 93 which crashed outside of shanksville,
pennsylvania, on september 11 2001, killing all 45 people on
board. the plane, a boeing 757-200, was flying from newark,
new jersey, to san francisco & is believed to have been
hijacked. exact details of what caused the crash are either
unknown or being kept under wraps, but a common
perception is that some of the passengers challenged the

hijackers, preventing the hijackers from reaching their target. details of the intended target are also either unknown or under wraps, but many believe it was heading for the white house. there appear to be many unanswered questions regarding these events & in the US there was speculation as to whether the plane had been shot down by their own military

orange roughie
a fish

fotos
some of the photographs described in this text can be seen at www.lloydrobson.com

algonquin
the algonquin hotel served as a daily haunt for the 'round table' - a group of 1920s new york critics, journalists & literati, which included dorothy parker. parker was played by jennifer jason leigh in the 1994 film 'mrs parker & the vicious circle'

UKinNY
the british council 'UKinNY' festival held in new york city, october 2001. following the events of 9/11 the festival was rededicated & renamed 'UKwithNY'. 'a manhattan montage' was written as a direct result of my involvement in the festival. i am grateful to the british council & wales arts international for allowing me the opportunity

tremorfa
a working class area of cardiff where my mother was raised

typex
typewriter correction fluid

cymraeg
a surviving welsh language

scarface
eddie ladd's excellent one-woman stage, dance, film & music performance which takes its lead from the movie 'scarface'. more information from www.dybli.fsnet.co.uk

lechaim
a toast; hebrew language equivalent of 'to life'

camo's
camouflage clothing

ciao
italian language equivalent of 'hi' or 'bye'

ground zero
site of the world trade centre. the day portrayed is sunday 28 october 2001 - the date of the memorial service held at ground zero to serve as some kind of funeral service for those who had lost loved ones. the planned silence at 2pm was broken by the sound of press helicopters overhead

b. i can see you

dreams of to say (2000)

justa little… (1998)

single-skinners
small cannabis/marijuana cigarettes made with only one paper

shroom, mush
magic mushrooms

bong
water pipe used for smoking hashish

living off lloyd street. full hot (2000)

jesus wants me for a sunbeam
christian song, words by nellie talbot, music by edwin othello
excello (circa 1900)

licka
a green, parsley gravy served in london pie & mash shops. it
should be spelt 'liquor'

cardiff cut & sissi
'cardiff cut' (parthian, 2001) & 'letter from sissi' (blackhat,
1997) are both prose poems by lloyd robson

durex
brand of condom

scheisse (scheiße)
deutsch language equivalent of 'shit'

buckenwald
a world war II concentration camp on the outskirts of weimar in
what used to be the german democratic republic (GDR), east
germany. after units from the 3rd US army liberated the camp
from nazi control (11 april 1945) they filed in local residents to
show them what had been happening on their doorstep. film
footage shows disbelief. near the camp a gigantic monument
overlooks the whole region from mount ettersberg. the
monument is eerily nazi in scale & fashion & its 'road of nations'
links three mass graves which have sunk over the years as the
bodies of camp inmates have decomposed. the camp was
taken over by the soviet army & served as soviet special camp
no.2 from 1945-50, an internment camp for people accused of
nazi activities. on stalin's birthday (21.12.51) the soviet
authorities handed the camp over to the east german
government which transformed buckenwald into the first ever

national memorial of the GDR. these days the woods around the camp contain 7,000 metal posts which commemorate 7,000 inmates who died at soviet special camp no.2 & were buried amongst the trees. there is also a camp museum. the lampshades made from the skin of dead inmates for the practical comfort of nazi camp staff are no longer on show because they are deemed too disturbing, like the rest of the camp isn't

blood road
buckenwald served as a nazi labour camp & inmates built roads, including 'blood road' which leads to the camp

schiller's house
home to german dramatist, poet & essayist friedrich schiller from 1802 to his death in 1805. along with goethe (who also lived in weimar) schiller was a major figure in german literature's 'sturm und drang' (storm & stress) period. word on the street has it schiller & goethe enjoyed a bier or two

blimburnt
reference to burn holes caused by 'hot rocks' of hashish falling from a spliff. your average habitual cannabis smoker hasn't got a decent (unburnt) t-shirt to their name

playoffs
part of the english football league promotion system

jedem das seine
deutsch language equivalent of 'everyone deserves their own'. this text was incorporated into the design of the gates at buckenwald concentration camp by the nazis, as a joke

for those in peril...
hymn by william whiting

clifton, st. mary's next to caroline
names of streets in both cardiff & llandudno

rosebery avenue
name of a street in both plymouth & llandudno. i once lived in the plymouth one

the great orme
the headland at llandudno. composed of carboniferous limestone, the great orme has served as neolithic burial site & home to many ancient settlements

coed
cymraeg language equivalent of 'trees'. its use here is aural & visual rather than literal

coch
cymraeg language equivalent of 'red'. its use here is aural & visual rather than literal

charles cross
a roundabout in plymouth built around the remains of a church bombed out during world war II. while living in plymouth i spent time within the church walls during various nites out, for various reasons. it sits directly in front of the city's main police station & offers the opportunity to disrespect history, religion, law & authority simultaneously. i regret disrespecting history

life's like that! (1998)

this poem is based on a true story

fao
for the attention of

i hoped i'd never (2001)

my father sent me a letter days before committing suicide. it arrived after his body had been found in a fume-filled car he had bought especially for the occasion, by someone who really shouldn't have chosen to walk the dog that day

echo
the south wales echo - cardiff's evening paper

abide with me
hymn by henry f. lyte (1847), set to 'eventide' by william h. monk (1861)

this is just to attach exhaust to hose (2001)

this poem is a cut-up of a fictional suicide note & william carlos williams' poem 'This Is Just to Say', a poem which through regular reworking by other poets could develop into its own recognisable haiku-style form. i recommend you read williams' original & then peter finch's 'All I Need is Three Plums' & 'The Plums'. then perhaps you should write one yourself (a poem, not a suicide note)

surround myself with busyness (2002)

cookie, worm, virus
computer terms. items that can be downloaded to your computer from external systems, usually without you knowing

c. *sense* of city road

edge territory
a previous collection of text & image from lloyd robson (blackhat, 1995)

for further information on city road or the project visit:
www.lloydrobson.com
www.senseofcityrd.freeuk.com
www.hyperaction.org.uk/cityroad/
www.peterfinch.co.uk

& read:
'the real street - lloyd robson's sense of city road'
by peter finch, planet magazine #144

d. life lite

notes from new york state (2002)

merlot, chianti
red wines

sam, skinny, heiny
beers; sam adams boston lager, skinny atlas light, heineken

bridgend prisoner of war camp story
during world war II there was a prisoner of war camp based near bridgend in south wales. after the war the italian camp inmates were released & allowed to return home to italy. a substantial percentage of them said *"bugger that"* or the italian equivalent & opted instead to stay in south wales, settling in nicely to the local communities

lucky luciano
charles 'lucky' luciano - sicilian-american gangster (1897-1962)

t.g.i friday's
an international chain of restaurants where the staff are encouraged to be tediously cheesy & wear daft uniforms

federal reserve washington hamilton jackson grant, annuit cœptis the great seal in good we trust
text from american bank notes. the federal reserve is the US central banking authority; washington, hamilton, jackson & grant are presidents featured on notes of various denominations; 'annuit cœptis' is written on the great seal featured on the back of the notes & translates from the latin as something like 'favourable to our undertakings'; 'in god we trust' has featured since 1861, supposedly because of increased religious sentiment during the american civil war

regina or rex
latin terms referring to the reigning queen or king

the bend sinister, devil child, cack hand
references to lefthandedness & the lefthanded

teeline
a form of shorthand

spanish gold
a confectionery styled to resemble a pouch of tobacco

woolco's
a spin-off from the woolworth chain of stores

top trumps
a range of card comparison games, featuring such fascinations as 'the world's top tractors'

nick o'teen
an early 1980s character used by british health authorities to discourage children from taking up smoking

zippo
brand of cigarette lighter

fags
british slang for cigarettes

monsters inc™
a disney animated film

united express
an american airline

bore da
cymraeg language equivalent of 'good morning'

co-ed
a female student at an american coeducational institution

llandaff, splott
areas of cardiff (llandaff's posh, splott's not)

dylan & r.s thomas
dylan thomas & r.s thomas - welsh writers. irrelevant of my opinion of them as writers, now they are dead their rôle within & perceived influence upon contemporary welsh writing is sometimes negative & oppressive

sheepshaggers
some thick as shit people like to dismiss the welsh as sheepshaggers. some welsh people have decided to claim the term as their own & turn its potency on its head, from insult to term of self-assertion

ych-a-fi
cymraeg language equivalent of 'yeuch' or 'yuck'

econolodge
chain of american budget motels

little house on the prairie
cheesy american tv programme which continues to annoy me

battle of the boyne
1690 battle at the river boyne, ireland, in which the protestant (mainly english) forces of william III (william of orange, a dutchman) beat the catholic (irish & french) forces of james II (the london-born king james VII of scotland). some dozyborn bastards are still squabbling about all this ancient religious royalist bullshit, reassuring each other of its & their own relevance

sbarro
american chain of pizza restaurants

i got it bad & that ain't good
song by duke ellington. this version recorded by lena horne

roll him over real easy / roll him over real slow
lyric from 'frankie & johnny', a traditional american folk song which has been recorded by numerous artists with many lyrical variations. this version was recorded by lena horne

charles bukowski
german-american author who seems to be as famous for his boozing as his writing (1920-1994). the event portrayed, where a woman asks if i'm mr. bukowski, really did happen. it took me a moment to realise she wasn't taking the piss

airforce one
the american presidential aeroplane

george dubya, clinton, his daddy
american presidents george w. bush (2000-), bill clinton (1992-2000), george bush (1988-1992). when george dubya was elected america may have felt pleased with itself but the

rest of the world groaned. here was an ignorant man intent on making up for his pappy's earlier posturing failure in the gulf war. george jnr is supposed to be a world leader yet in 2002 he disrespectfully referred to the pakistani people as 'pakis'. america, listen to me: the man's an oil, ammo & profit fixated loon. maybe that appeals to ya, but he's gonna get our boys killed, yours too

when she sleeps (2000)

this poem is, was & always will be for sally wallace

trout fishing in america
prose by richard brautigan

get over it get down to it... (2000)

armsdeal in adamsdown (2001)

most of the text is from a parts listing for the panavia tornado GR mk.1 jet fighter aeroplane, as used in the 1991 gulf war

the clifton
a pub in adamsdown, cardiff

fin
refers to a part of the plane but is also meant to be read as 'fin' - the français language equivalent of 'end', although it's use here is more suggestive of 'end of' or 'no more'

bap-bah! (2001)

in the first draft '*bap-bah!*' was a sample of that big brassy punctuation in glenn miller's 'in the mood' but now i think it's a more direct sound & less hinged than miller's. no doubt it'll mutate further, may even turn into a live 20 minute solo... *nice*

after the refit of the clifton street spar (2001)

spar
a brand of franchised local shop. doing a weekly shop in a spar gives me a feeling similar to vomiting in someone's kempt garden - it's absolutely necessary at the time but leaves me despairing of myself afterwards

stella artois
belgian lager

sparables
headless shoe nails

sparaxis, spartina
plants

spathes
leaves around a flower cluster

spartakist group
the beginnings of the german communist party

rosa luxemburg
founder member of the spartakist group. she was arrested & murdered during the 1919 berlin revolt

sparging
part of the brewing process (to moisten by sprinkling)

sparling, sparoid & porgy
fish

spartito
musical score

khachaturian's theme to 'the onedin line'
the theme music to the 1970s BBC tv programme 'the onedin line' was from aram khachaturian's ballet score 'spartacus'

spartans
citizens of the ancient greek city of sparta

spartacus
1st century BC thracian gladiator loosely based on a cleft-chinned yank actor

B&H
benson & hedges brand cigarettes

hoover haiku (1999)

dedicated to those of you who like to involve small furry mammals in your sexlives

hoover
a brand of vacuum cleaner previously manufactured in merthyr tydfil, south wales (in pontcanna it's pronounced 'œuvre')

me lips... (1997)

datsun
previous brandname of nissan cars

patagonian
patagonia is a region of argentina. as far as i'm aware it's the only place in the world, apart from wales, that recognises cymraeg as one of its active languages

amazon, antelope, alacrity, ardent, active, avenger, arrow & ambuscade were all royal navy type 21 frigates; *purdey* was the name of the helicopter aboard HMS avenger (named after

joanna lumley's character in 'the new avengers' tv series). my brother mark served aboard a number of type 21's, notably HMS avenger during the falklands war

exocet
the highly effective french missile used by the argentinian forces against the british navy

satellite of love, lou reed, nico
nico was a model, recording artist & sometime vocalist with the velvet underground; lou reed was a permanent member of the velvet underground; 'satellite of love' is from lou reed's 'transformer' album (1972)

coffeeshops, balou
amsterdam cannabis-smoking venues

yogi, boo boo, jellystone
references to the hanna barbera 'yogi bear' cartoons

officer dibble, see ya tc
references to the hanna barbera 'top cat' cartoons

tcp
a brand of antiseptic products

vesta
a brand of dehydrated meals. when i was a kid these were considered a treat in our house

galileo
a jupiter-bound space probe launched in 1989, named after galileo galilei (1564-1642), italian astronomer, physicist & one of the founding fathers of modern science. his evidence supporting the idea that the planets revolve around the sun was rejected by the catholic church & led to his torture at the

hands of the inquisition. religion eh?

parkes, hubble
telescopes. parkes observatory in new south wales, australia, contains the largest radio telescope in the southern hemisphere & is near me aunty jean's house. the hubble space telescope is an orbiting observatory & come to think of it isn't anywhere near me aunty jean's house

discovery
the name of a NASA space shuttle

roswell
reference to the alleged discovery of a crashed UFO at roswell, new mexico in 1947. some people believe roswell is a huge US governmental cover-up, others believe it's a load of conspiracy bullshit for people with too much time on their hands

wenglish
one of the names given to the so-called 'english' language spoken in a welsh dialect

scorchio
very hot. the word began life on the 'fast show' tv programme

prozac
an anti-depressant that sparked 'drug of the nineties' claims (along with ecstasy, obviously)

a streetcar named desire
1947 play by US playwright tennessee williams (1911-83)

popcorn kist
a play on the 'sunkist' brand of popcorn

northern lites
a stable strain of marijuana

e. bbboing!

imagine (2002)

imagine
reference to the title of a song by john lennon

adolphe sax
inventor of the saxophone range of instruments patented in 1846 (belgium, 1814-94). a sax is a brass reed instrument

coltrane, bird, diz, eldridge, miles
american jazzmen extraordinaire. john coltrane (saxophone, 1926-67), charlie 'bird' parker (saxophone, 1920-55), dizzy gillespie (trumpet, 1917-93), roy eldridge (trumpet, 1911-89), miles davis (trumpet, 1926-91)

nijinsky, nureyev
ballet dancers extraordinaire. vaslav nijinsky (ukraine, 1890-1950), rudolf nureyev (russia, obtained political asylum in france 1961, austrian citizen 1982, 1938-93)

nellie kim, korbut, comaneci
gymnasts extraordinaire. nellie kim (kazakhstan, 1957- , represented USSR, winner of 5 olympic gold medals), olga korbut (belarus, 1956- , represented USSR, winner of 4 olympic gold medals), nadia comaneci (romania, 1961- , represented romania, defected to the USA 1989, winner of 5 olympic gold medals)

cruyff, john charles
footballers extraordinaire. johan cruyff (holland, 1947- , creator

of the 'cruyff turn' & a master in the dutch concept of 'total football'), john charles (wales, 1931- , equally effective in defence or attack, in 1957 juventus payed a then world record fee to take him to italy where he was voted italy's 'player of the year' & was dubbed 'il gigante buono' - 'the gentle giant'. later played for roma & cardiff city)

karpov, kasporov
chess masters extraordinaire. anatoly karpov (russia, 1951- , world champion 1975-85), gary kasparov (azerbaijan, 1963- , beat karpov in 1985 to become youngest world champion)

will carlos, burroughs, kerouac, olson, black mountain
north american writers extraordinaire. william carlos williams (1883-1963, helped establish an american idiom in print), william s. burroughs (1914-97, innovator in collage, cut-up & the novel form, *"cosmonaut of the inner space"*), jack kerouac (1922-69, innovator in spontaneous prose & musical narrative), charles olson (1910-70, developer of 'projective verse', syntax, space & sound, rector of black mountain college), black mountain (1933-57, experimental art college in north carolina, students included john cage & willem de kooning, staff included olson, robert creeley & robert duncan)

kurt works (2001)

kurt schwitters
schwitters (1887-1948) was a german dadaist writer & artist. he wrote a number of phonetic poems, notably 'ursonate in urlauten' - a sonata in primeval sounds. he moved to britain in 1940 to escape nazi persecution & stayed for the rest of his life. none of his published works were written in cymraeg, possibly because there's no K in its alphabet, however there is no documentary evidence proving he did not play for cardiff city football club during this time...

i first encountered schwitters' work thanks to olaf steiner, an english teacher in sömmerda, germany, so thanks to him & the steiner family. this is me gagging about with serious ideas & getting a grin out of it, which could well be the point

K
why does this work focus on the letter K? a number of reasons: K is for kurt & for kunst; the hard, harsh or angular pronunciation of the letter C in a cardiff accent is often shown in print as a letter K; the letter K provides a kind of linguistic opposition between deutsch & cymraeg languages insomuch as deutsch words which might begin with a C are mostly changed so they begin with a K, whereas cymraeg has no K in its alphabet at all; i wanted to indulge my fond affection for sesame street & create an opportunity to say *"this week's poem is brought to you by the letter K"*. i'm sure there are other reasons but i haven't discovered them yet

football card
the design of the card is similar to that of the topps chewing gum series i collected as a kid, circa 1978

kerr kinkladze kanu, etc
K-named footballers who all began the 2000-01 season playing in the english premier league (source: rothmans football yearbook 2000-01)

kunst
deutsch language equivalent of 'art'

achtung! (1998)

achtung!
deutsch language equivalent of 'attention!'

the british stammering association (bsa)
since this poem was written the bsa has changed its vision statement to "a world that understands stammering". fine. having dismissed the abhorrent idea of the vision statement featured in this poem, the spotlite can now return to the wonderful work they do, but what fucking planet were they on at the time?

brown shirt, gas shower
allusions to the nazi ideas of purity & clearance

schtum!
an intentional misspelling of 'stumm' - the deutsch language equivalent of 'dumb' or 'silent'

planecrash loose haikus (3 of 6) (2000)

beyond burroughs (2000)

a visual text which takes as its starting points a quote from 'nova express' (grove press, 1964) by william s. burroughs & an image based on a photograph by jon blumb (1992) of burroughs in a recording studio

sandinista tequila tabasco... (2000)

the mayor, aristo
characters from 'cardiff cut' by lloyd robson

el real
a town in panama

yellowbox
reference to 'old el paso' brand mexican-style pre-packaged meals

coup d'état
violent or illegal seizure of power

the clash, sandinista
legendary british punk/new wave band 'the clash' issued an album called 'sandinista!' (1980), named after the nicaraguan revolutionaries

mucho
espanol language equivalent of 'much' (you knew that, surely)

splash (1997)

splash is an original remix of a found text; of a rough draft i saved from the bin; of an essay entitled 'language constitutes strategic power' by sally wallace. the handwritten amendments, accidental stains (fruit squash) & subsequent ink movements are results of her editing process. this 'poem' is a result of my editing process

language notes (1999)

references:

burr v (1995) 'an introduction to social constructionism'
london: routledge
foucault m (1972) 'the archaeology of knowledge'
london: tavistock
howe d (1994) 'modernity, postmodernity & social work'
BJSW #24 513-532
wallace s (1997) 'theoretical perspectives: language constitutes strategic power'
unpublished

splash goes kolor (2001)

acknowledgements

thanks to the following for publishing earlier versions of some of the works in *bbboing!*:

academi (web/wales), blackhat (web/wales), fire (england), gendaishi techo (japan), genius in progress (japan), louder arts (web/USA), midnight press (japan), new welsh review (wales), nth position (web/USA), parthian (wales), planet (wales), poetry wales (wales), rattapallax (web/USA), red poets' society (wales), slope (web/USA), tears in the fence (england).

& big thanks to the following:

sally wallace for her incredible love & support over the years - thanks sal; chris torrance for being such a poet's poet & good friend; parthian books who work so hard for their authors & welsh writing in general; mike & paul who did so much for blackhat; alan & joe at alan walsh reprographic; reach for taking me to germany in 1997 & for everything else; dederon sound systems; the steiner family & willi; oli greibel for advice on the german language; kenji & keiko fukuma in tokyo; robert minhinnick; wales arts international for assisting me with my travels & readings tours; the arts council of wales for the writer's bursary i'd been desperately in need of for several years; everyone at academi, the welsh literature promotion agency; the writers & editors of terrible work & fire magazines in particular, but also the many marvellous writers & small press editors of wales & england who have been so willing to share their wisdom, insight, enthusiasm & friendship... *gush gush, blub blub...*; the supportive & tolerant hardcore who, uh, *borrowed* stationery for me from their places of employment; & of course to everyone who features in the events portrayed in these texts - *we had a laff didn't we?*

also by lloyd robson:

cardiff cut
isbn: 1 902638 16 6, £5.99 / $14.95
neither truth nor fiction, taken from real life or what seemed for
an instant, cardiff cut is witty, obscene, defiant; a drug-fuelled
anarchic joycean monologue steeped in the city of cardiff

*"so utterly alive... open cardiff cut at random & you'll find
writing of quality, every page boils with it... a vital tonic,
a national treasure"*
- niall griffiths, planet magazine

*"innovative, hilarious, exhilarating... this frantic sometimes
savage eruption of chaos & poetry will leave you exhausted...
great stuff!"*
- melanie daley, big issue

*"an authentic & original voice able to deliver streetwise power
punches with the deceptive subtlety of true ringcraft. a
tonsil-ripping cocktail of a book. down it in one!"*
- john harrison, new welsh review

available from:

PARTHIAN BOOKS

the old surgery, napier street, cardigan, SA43 1ED, wales, uk

for more information visit:
www.parthianbooks.co.uk

USA distribution:
www.dufoureditions.com

hey bbbaby!

nice of you to pick me up
now flip me
&
woancha warm your hands
next time?

love
your friend the bbbook
xxx